THE BRANCH LINES OF
WARWICKSHIRE

COLIN G. MAGGS

AMBERLEY

Front cover: A 480 Messrs Courtald, Coventry, 0-4-0ST *Rocket*, Peckett Works No. 1722 of 1926, seen here on 26 April 1968. *Revd Alan Newman*

Back cover: A411 A National Coal Board 0-6-0ST at Baddesley Colliery, 29 September 1967. *Revd Alan Newman*

First published 1994
This revised edition published 2011

Amberley Publishing
Cirencester Road, Chalford,
Stroud, Gloucestershire, GL6 8PE

www.amberleybooks.com

British Library Cataloguing in Publication Data.
A catalogue record for this book is available from the British Library.

ISBN 978-1-84868-346-4

Typesetting and Origination by Amberley Publishing.
Printed in Great Britain.

Contents

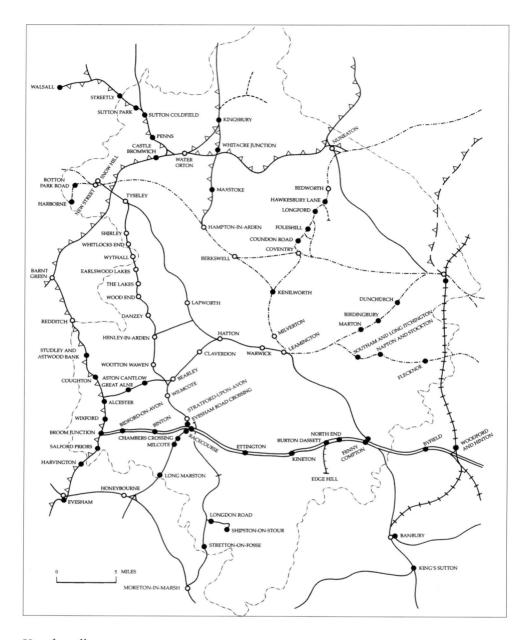

Key for all maps

———	Great Western Railway
—·—·—	London and North Western Railway
△△△	Midland Railway
┼┼┼	Stratford-upon-Avon and Midland Junction Railway
△ △	Great Central Railway
++++	Edge Hill Light Railway
‑ ‑ ‑ ‑	Industrial Railway
○	Station open in 2011
●	Station closed in 2011

Introduction

At first the railway map of Warwickshire seems very complicated, but on close inspection a pattern emerges. Towards the north is the London and Birmingham Railway, which later became part of the London and North Western Railway, its Warwickshire portion running between Rugby and Birmingham. South of this artery a branch ran to Leamington, Warwick and Daventry and another northwards to Nuneaton. South-west of the LNWR was the Great Western Railway. This company had a parallel line from Birmingham to London, which kept a respectful distance from that of its rival; in fact in Warwickshire neither company made inroads into the other's territory.

The Midland Railway's main line in the area was that which ran from Bristol and Gloucester through Birmingham to Derby. One Warwickshire branch was the Studley and Astwood Bank to Salford Priors section of the Barnt Green to Ashchurch loop; another the Whitacre to Hampton-in-Arden branch connecting with the LBR; the third MR branch being the Water Orton to Streetly section of the Walsall line. The Stratford-upon-Avon and Midland Junction Railway ran from Broom Junction, on the Barnt Green to Ashchurch line, to Towcester on the Northampton and Banbury line making connections with the MR, GWR, Great Central Railway and LNWR, but unfortunately for its finances did not give or take much through traffic.

Preceding all these lines was the Stratford and Moreton Railway, a horse-worked single track line built by Thomas Telford and opened in 1826. Although its principal function was carrying coal from the Stratford-upon-Avon Canal and returning with stone and agricultural produce, it carried passengers as well. Following the opening of the Honeybourne to Stratford-upon-Avon branch by the Oxford, Worcester and Wolverhampton Railway in 1859, the Stratford end of the tramway was almost abandoned, though the track was not actually lifted until 1918. From Longdon Road a Stratford and Moreton Railway branch ran to Shipston-on-Stour, and in 1889 the line from Moreton to Shipston was modified for locomotive working.

The London and Birmingham Railway, one of the first main lines in the country, was authorised in 1833, opened from Birmingham to Rugby on 9 April 1838 and through to Euston the following year. Dissatisfied with the high carriage rates

of the monopolistic LBR, Birmingham manufacturers proposed a competing line, the Birmingham and Oxford Junction Railway, to run from Birmingham to a junction with the Oxford and Rugby Railway at Fenny Compton, the ORR taking trains onwards to the GWR at Oxford and to Paddington. As it was believed that the mixed gauge Birmingham and Oxford Junction Railway would be sold to the GWR, the LNWR acquired four-fifths of the shares to prevent this, but the GWR successfully contested the action in court and the line was absorbed by the GWR. The latter, which had taken over the Oxford and Rugby Railway, opened a single broad gauge line from Oxford to Banbury in 1850. Two years later, on completion of the line from Fenny Compton, the Oxford to Banbury line was doubled and the gauge mixed. Standard gauge trains, however, were not able to run through from Birmingham to Paddington until 1861.

The line from Oxford to Honeybourne and Worcester was built by the Oxford, Worcester and Wolverhampton Railway, known from its initials as the 'Old Worse and Worse'. Its single mixed gauge line opened in 1853, the company using some of its own standard gauge stock and hiring the remainder from the LNWR. In 1860, it became the West Midland Railway, and three years later was absorbed by the GWR.

The Birmingham and Derby Junction Railway was incorporated to build a line from Stechford on the London and Birmingham Railway, 3¾ miles east of Birmingham, but as the Stonebridge Railway was constructing a line from Whitacre to Hampton-in-Arden, which would give a direct run towards London, it was decided that in order to save money by not building the line from Whitacre to Stechford, trains from Derby to Birmingham would reverse on to the LBR at Hampton. Therefore the line from Whitacre to Stechford was not built initially. As the LBR charged heavy tolls to the BDJR for running from Hampton to Birmingham, the BDJR decided to construct an independent line from Whitacre to Birmingham. The BDJR became part of the Midland Railway in 1844.

The East and West Junction Railway was formed to transport Northamptonshire iron ore to South Wales blast furnaces for which local supplies had been exhausted; though in fact, this hope of using Northamptonshire ore was never fully realised as Spanish ore proved cheaper. The EWJR was authorised in 1864 to build a line from Towcester to Stratford-upon-Avon. It opened from Fenny Compton to Kineton in 1871 and to Stratford two years later. The extension from Stratford to the MR at Broom Junction was floated as a separate company, the Evesham, Redditch and Stratford-upon-Avon Junction Railway, which opened in 1879. In 1908 the Stratford-upon-Avon, Towcester and Midland Junction Railway, the East and West Junction Railway and the Evesham, Redditch and Stratford-upon-Avon Railway all amalgamated to form the Stratford-upon-Avon and Midland Junction Railway. The latter's initials gave rise to the nicknames 'Slow and Muddle Junction' and 'Slow, Mournful Journey'.

In 1960, the connection at Fenny Compton was remodelled to provide a facing connection in order to facilitate the running of iron ore trains from Banbury to

South Wales to form an alternative route to the Banbury and Cheltenham Direct Railway, part of which had by then been closed. A new junction was also put in at Stratford, south of the Racecourse station. In 1965, the line was closed from the Ministry of Defence Central Ammunition Depot sidings at Burton Dassett to Stratford, the line from Fenny Compton to Burton Dassett being sold to the Ministry of Defence on 18 July 1971.

The Edge Hill Light Railway formed a branch off the SMJR, and was opened as recently as 1920. The quarries were worked until 1925, closure coming about as a result of a reduction in demand for English ore. After closure the railway lay derelict for seventeen years until dismantled for scrap during the Second World War.

In order to have some logical and approximate historical sequence, the branch lines of those railways, which eventually became part of the LMS group, are described from north to south, and those of the GWR group from south to north. The county boundary has varied throughout the years and that chosen is as it was in steam days.

Grateful thanks are due to Kevin Boak and Colin Roberts, for various forms of assistance.

It should be noted that train times in this book follow the form given in the public timetables. Therefore, photographs up to June 1963 are presented using the twelve-hour clock, and photographs after that date use the twenty-four hour clock.

HOLIDAY RUNABOUT TICKETS

IN

THE MIDLANDS

DURING

INDUSTRIAL and AUGUST HOLIDAY WEEKS

29th July—11th August 1956

EACH AREA

Second **25/-** Class

(Children under fourteen—half-fare)

- TICKETS AVAILABLE 7 DAYS SUNDAY TO SATURDAY (inclusive)
- UNLIMITED NUMBER OF JOURNEYS WITHIN THE AREA
- BREAK OF JOURNEY ALLOWED AT ANY STATION
- TAKE YOUR BICYCLE FOR 12/6
- TAKE YOUR DOG FOR 6/3

These tickets are issued subject to the British Transport Commission's published Regulations and Conditions applicable to British Railways exhibited at their stations, or obtainable free of charge at Station Booking Office.

Further information will be supplied on application to Stations, Official Railway Agents or to G. F. Luther, District Passenger Manager, London Midland and Western Regions, New Street Station, Birmingham 2. Telephone MIDland 2740 ; H. Bullough, District Commercial Manager, London Road, Leicester, Telephone 5542 ; C. E. Drew, District Commercial Manager, Shrub Hill Station, Worcester, Telephone 3241.

June, 1956 B.R. 35008.1

Holiday Runabout tickets handbill, June 1956.

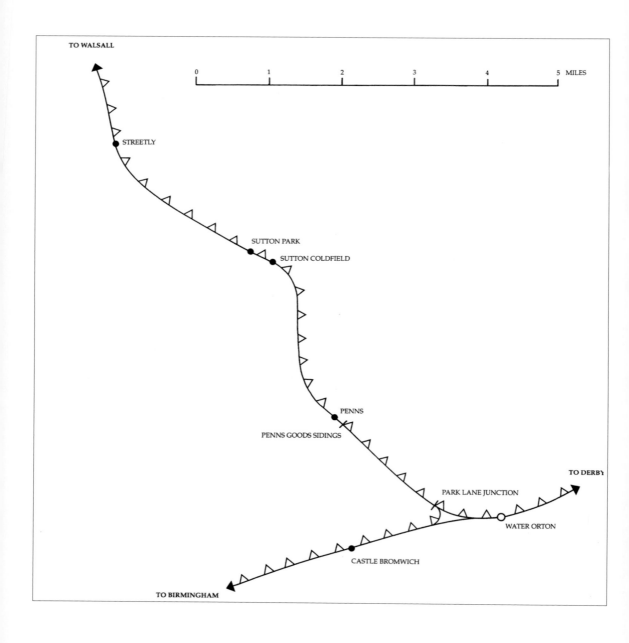

TO WALSALL

0 1 2 3 4 5 MILES

STREETLY

SUTTON PARK

SUTTON COLDFIELD

PENNS

PENNS GOODS SIDINGS

TO DERBY

PARK LANE JUNCTION

WATER ORTON

CASTLE BROMWICH

TO BIRMINGHAM

Water Orton to Streetly

The branch from Water Orton through Streetly to Walsall, authorised on 6 August 1872, was built by the Wolverhampton, Walsall and Midland Junction Railway, a company that had strong links with the Midland Railway and was absorbed eventually by an Act of 30 July 1874. Care for the environment is by no means a modern phenomenon, for when the line was planned a public outcry arose when it was realised that it was to run through Sutton Park. This was one of the first occasions when ordinary people, as opposed to landowners, objected to scenery being spoilt. The objectors' dissatisfaction was overcome when they discovered that the line would give them cheaper coal! This line through the Park was expensive as land cost £6,500 for the 2-mile-long strip.

The line's contractor, Joseph Firbank, estimated the total cost of the 8-mile long line at £175,000, but, as on so many lines, these costs were exceeded and eventually rose to over £400,000. The aqueduct at Daw End carrying the Rushall Canal proved awkward to build, but most of the extra expense was caused by the provision of unnecessary items demanded by a temporary engineer employed by the Midland Railway.

The branch was opened to goods on 19 May 1879 and to passengers on 1 July, trains running from Birmingham New Street to Wolverhampton High Level. Passenger stations were provided at Penns, Sutton Coldfield, Sutton Park, Jervis Town and Aldridge. There were several changes of name: Penns became Penns for Walmley on 17 October 1936; Sutton Coldfield had 'Town' added on 1 May 1882, the suffix being removed on 1 April 1904 and restored on 2 June 1924; Jervis Town was renamed Streetly in around July 1879.

During the First World War, as an economy measure from 7 January 1917, Sutton Park to Aldridge was reduced to a single line worked by tablet. Double track was restored on 20 March 1921. Sutton Coldfield Town station, less than half a mile south of Sutton Park station, closed on 1 January 1925 and had no goods depot. The branch was particularly busy in August 1957 when the Boy Scouts' Jubilee was held in Sutton Park. Stopping passenger services were withdrawn on 18 January 1965, goods stations having been closed at Sutton Park on 7 December 1964 and at Penns, about half a mile south of the passenger station, on 1 February 1965. Streetly had no goods depot. From 7 January 1968

the branch was made a goods-only line, though from 1970 to 1983 was used by certain summer seasonal passenger trains on Friday evenings and Saturdays, becoming a regular passenger line again on 2 December 1984.

East of Castle Bromwich the branch makes a triangular junction with the main Birmingham to Derby line, Castle Bromwich Junction being nearest Birmingham, Water Orton Junction on the east, and Park Lane Junction at the northern apex. Castle Bromwich to Streetly is mostly uphill, the ruling gradient being 1 in 100.

In August 1887, the passenger train service consisted of fourteen each way and three on Sundays, this continuing with few alterations until the First World War, though the timetable for April 1910 showed four trains on Sundays. In July 1922, only eleven ran each way daily and three on Sundays. By July 1938 the pattern had changed. Twelve trains ran throughout with four additional ones from Sutton Park to Walsall and return, while the Saturday timetable showed an additional four of these short workings. On Sundays two through trains and seven short workings ran. The push-pull service of local trains was worked by ex-LNWR Class 1P 2-4-2Ts. In June 1958, the branch was most unusual in having more trains on Sundays than on weekdays, the numbers being eight and five respectively, though the former ran the whole length of the branch and the latter formed just a shuttle service between Walsall and Sutton Park.

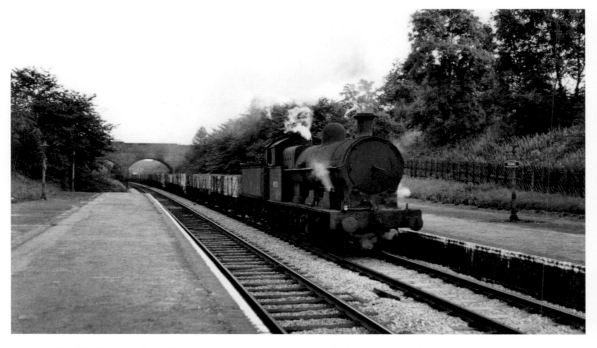

Ex-LNWR G2a class 7F 0-8-0 No. 49210 (9D, Buxton shed) plods through Penns towards Streetly, 5 September 1959. Some members of the class, including No. 49120, were fitted with a tender cab. *Michael Mensing*

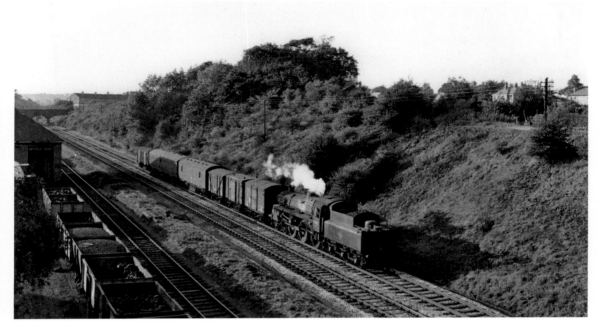

BR Standard Class 4 4-6-0 No. 75022, just south of Penns station, heads a parcels train comprising a mixture of stock, towards Park Lane Junction, 5 September 1959. *Michael Mensing*

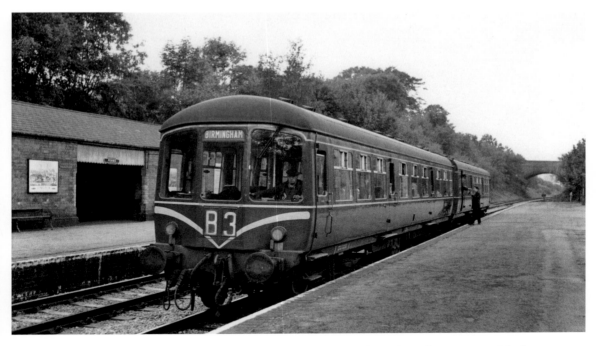

A two-car Park Royal DMU calls at Penns on 5 September, while working the 6.54 p.m. Walsall to Birmingham New Street. The driver is dressed in steam engine uniform. *Michael Mensing*

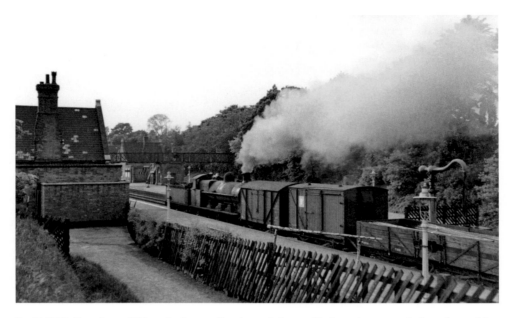

Ex-LNWR G2a class 7F No. 48964 trundles through Sutton Park station towards Streetly, 30 May 1959, with a mixed freight. No. 48964 was not withdrawn until April 1962. The van nearest the photographer contains Portland cement and the long open wagon carries pipes. Notice the typical MR fencing, gas lighting and the superbly shaped water column. *Michael Mensing*

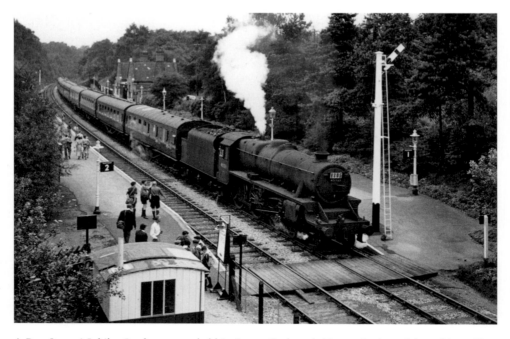

A Boy Scouts' Jubilee Jamboree was held in Sutton Park and this required special workings. Here Stanier Class 5 4-6-0 No. 45333 starts emptying coaching stock from an excursion away from Streetly, 4 August 1957. The train had come from Liverpool and No. 45333 was shedded at 8E, Liverpool Brunswick. *Michael Mensing*

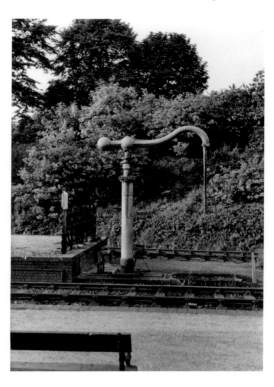

Right: Sutton Park station water column seen on 30 May 1959, with 'MR CO' cast on. Notice the chain to prevent the arm from blowing in the wind and thus fouling the loading gauge. Nearby is a brazier that was lit in cold weather to prevent the water freezing. *Michael Mensing*

Below: Ivatt Class 2 2-6-2T No. 41220 (3C, Walsall) passes through Sutton Park east of Streetly, 4 August 1957. The apparatus for pull and push working can be seen on the left of the smoke box. *Michael Mensing*

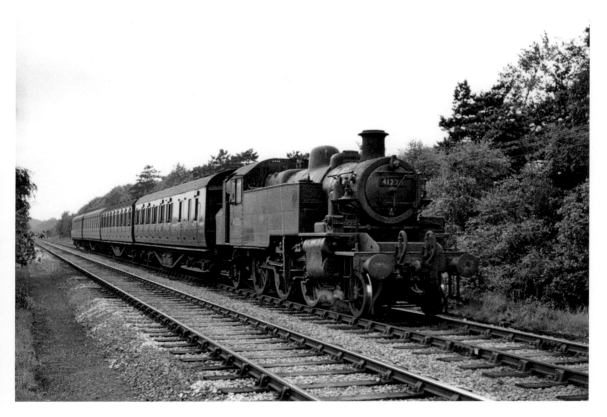

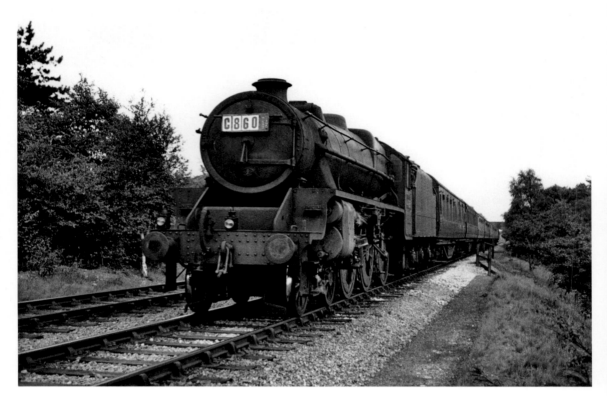

Stanier Class 5 4-6-0 No. 44762 (5A Crewe North) with Timken roller bearings, passes through Sutton Park, 4 August 1957, and approaches Streetly, heading a train of empty coaching stock to form a return excursion from Streetly to Oldham. The chalk lettering to the right of C860 reads 'Sunday Board'. No. 44762 was withdrawn in January 1966 from 6C Birkenhead. *Michael Mensing*

Table 262 **BIRMINGHAM, SUTTON PARK, and WALSALL**

Week Days only

Miles		a.m		a.m		p.m		p.m		p.m		p.m								
	Birmingham (New St) dep	7 18	..	8 13	..	1 8	..	5 35	..	6 35	..	8 5
2	Saltley	7 24	..	8 19	..	1 14	..	5 41	..	6 41	..	8 12
5¼	Castle Bromwich	7 30	..	8 25	..	1 20	..	5 47	..	6 47	..	8 19
6½	Penns. for Walmley	7 37	..	8 32	..	1 27	..	5 54	..	6 54
10	Sutton Park	7 43	..	8 38	..	1 33	..	6 0	..	7 0	..	8 29
13½	Streetly	7 49	..	8 44	..	1 39	..	6 6	..	7 6	..	8 35
15¾	Aldridge	7 55	..	8 50	..	1 45	..	6 12	..	7 12	..	8 41
17¾	Walsall arr	8 1	..	8 56	..	1 51	..	6 18	..	7 18	..	8 47

Week Days only

Miles		a.m		a.m		p.m		p.m		p.m										
	Walsall dep	7 8	..	8 10	..	1 40	..	5 43	..	6 37
1½	Aldridge	7 15	..	8 17	..	1 47	..	5 50	..	6 44
4¼	Streetly	7 20	..	8 22	..	1 52	..	5 55	..	6 49
7½	Sutton Park	7 25	..	8 27	..	1 57	..	6 1	..	6 54
8¾	Penns. for Walmley	7 31	..	8 33	..	2 3	..	6 7	..	7 0
12¾	Castle Bromwich	7 37	..	8 39	..	2 9	..	6 16	..	7 7
15¼	Saltley	7 45	..	8 46	..	2 17	..	6 24	..	7 16
17¾	Birmingham (New St) arr	7 51	..	8 52	..	2 23	..	6 30	..	7 24

Sutton Park line timetable, October 1941.

The Kingsbury Branch

The Kingsbury branch, an important mineral line about 5 miles in length, was built under the Midland Railway's (Additional Powers) Act of 28 July 1873, which empowered the company to build a branch from Kingsbury on its Birmingham to Derby main line, to serve Kingsbury, Birch Coppice, Hall End and Baxterley Park (Baddesley) collieries, the latter also linking with the LNWR's Trent Valley line at Atherstone. The Kingsbury branch opened to goods on 28 January 1878, being worked by pilot guard, as the LMS 'Appendix to the Working Timetables' (1937) stated:

> The Kingsbury Branch is, from 11 a.m. until 7 p.m. each weekday, worked by pilot guard without tickets. The pilot guard's badge is a metal plate lettered 'Pilot Guard, Kingsbury Branch'. The pilot guard will have possession of the staff, which must be shown to each driver. No train not accompanied by the pilot guard must stop at Kingsbury Colliery Sidings for traffic purposes between 11 a.m. and 7 p.m. on weekdays, unless special instructions are given by the pilot guard for it to do so.
>
> The pilot guard during the time he is on duty must accompany every train between Hall End Sidings and Baddesley Colliery.
>
> Freight trains may, when necessary, during the time the pilot guard is on duty, be assisted by an engine in the rear from Kingsbury Junction to Kingsbury Colliery Sidings or Hall End Sidings. The pilot guard must travel on each engine assisting the train in the rear.
>
> Wagons must be taken in front of the engine from Hall End Colliery Sidings to Baddesley Colliery. A brake van, in which a guard must ride, must be taken in front of the wagons.
>
> *Birch Coppice Colliery Branch*
> Wagons for the colliery must be drawn into No. 1 siding alongside the Birch Coppice Colliery Branch by the LMS engines, which must return to the Kingsbury Branch end of the sidings over the Birch Coppice Colliery branch.
>
> The single-armed signal fixed at the colliery end of the sidings, alongside the Birch Coppice Colliery Branch, must be kept exhibiting the 'Clear' signal, except where

required to be placed in the 'Danger' position for the protection of LMS trains working on the Birch Coppice Colliery Branch and the sidings alongside it.

Before any engine or vehicle is allowed to enter upon the Birch Coppice Colliery Branch or the sidings alongside it, the signal must be placed in the 'Danger' position by the LMS staff to intimate to the staff in charge of the Colliery Company's engines that the LMS engine has left the sidings and the branch line is clear, when it must be again placed in the 'Clear' position.

A telephone is provided near the connection between the Kingsbury Branch and the Birch Coppice Colliery Branch to enable guards and shunters to communicate with the Colliery Weighing Machine Office and the Foreman's Office at Kingsbury Branch Sidings.

As there was a down gradient from the Kingsbury Colliery spur to the branch sidings, loaded wagons were run from the pit towards these by gravity, eventually being shunted, again by gravity, from the end of the spur into the branch sidings.

Sometime prior to 1914, the MR ran a workmen's train from Tamworth on to the Kingsbury branch to serve the pits between Kingsbury and Atherstone. The train was worked on the branch jointly by Midland and colliery company locomotives. This passenger working ceased on 7 December 1928.

At Kingsbury, the five traffic sidings parallel with the main line held 160 wagons, mostly empty and awaiting transfer to collieries on the branch, though one of the roads held damaged wagons unfit to travel. The nest of eight sidings, placed parallel with the branch after it had curved from the main line, held 365 loaded wagons ready to be worked to their destinations. Although most of the inward wagons were empty, some carried pit props.

In pre-grouping days MR Class 2 and Class 3 0-6-0s were used for shunting and some branch working, while in later steam days a Class 4F 0-6-0 was sent daily from Saltley, carrying enough coal to last twenty-four hours. Water was no problem as a column was provided at Kingsbury. The collieries had their own locomotives for shunting at the pits and moving wagons to and from the branch sidings at Kingsbury. Baddesley Colliery had an interesting stud, including an 0-4-4-0T Garratt *William Francis*, built by Beyer, Peacock and Co. Ltd in 1937.

Hall End Sidings were taken out of use on 28 March 1983, and the Kingsbury branch closed entirely in March 1989.

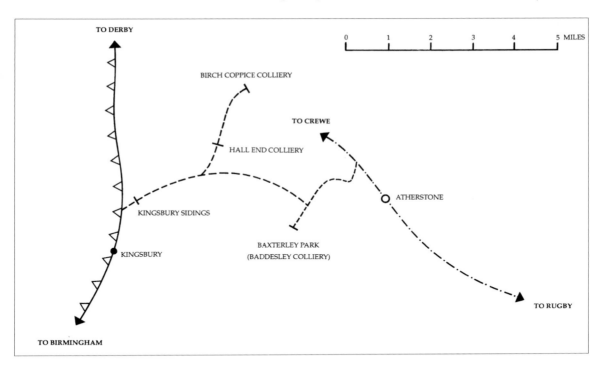

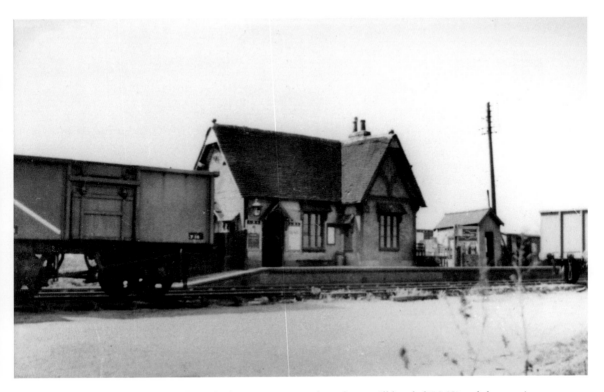

Kingsbury station, probably in the late 1950s. Poster boards are still headed 'LMS' and the running-in board is an LMS pattern. *Author's collection*

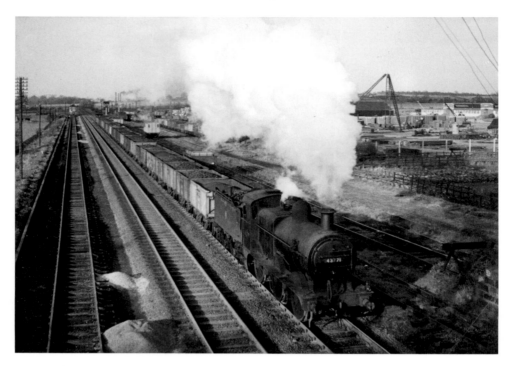

Ex-MR Class 3F 0-6-0 No. 43771 (21A Saltley), leaves the colliery line north of Kingsbury station, 2 November 1957. No. 43771 was withdrawn from service in January 1959. *Michael Mensing*

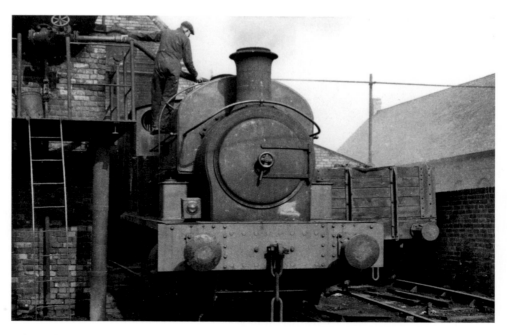

John Robert, a Manning Wardle 0-6-0ST, Works No. 1891 and built in 1916, takes on water at Birch Coppice engine shed, 24 April 1963. *Revd Alan Newman*

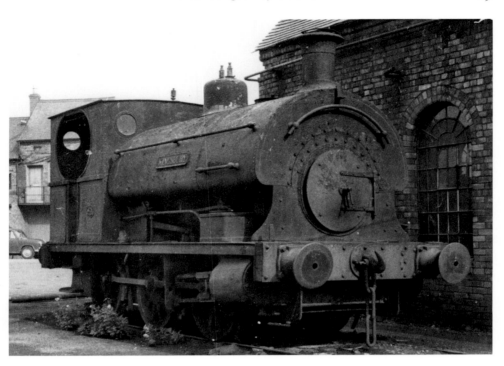

Kingsbury, a Peckett 0-6-0ST, Works No. 867, built in 1900, an ex-Kingsbury Colliery engine, seen here at Birch Coppice Colliery, 24 April 1963. *Revd Alan Newman*

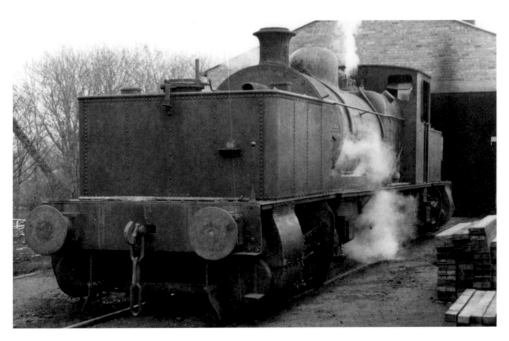

0-4-4-0T *William Francis* at Baddesley Colliery, 24 April 1963. Its nameplate is on the side of the boiler. This Garratt was built by Beyer Peacock in 1937, Works No. 6841. *Revd Alan Newman*

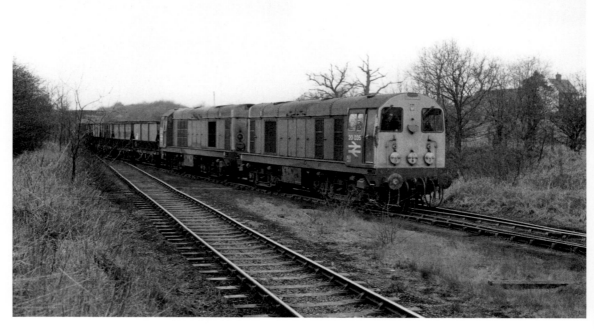

Class 20 diesel-electric No. 20035 at the head of a train of empty coal wagons to Birch Coppice Colliery, 7 March 1978. The line in the foreground comes from Baddesley Colliery. *Revd Alan Newman*

The Stonebridge Junction Railway: Whitacre to Hampton-in-Arden

The Birmingham and Derby Junction Railway, linking Hampton (on the London and Birmingham Railway) and Derby, was authorised by Act of 19 May 1836, and created a rather indirect route from Rugby and Birmingham to Derby. Construction began in 1838 and was unusually rapid, the directors making their first inspection trip over the whole line on 29 May 1839. It was formally opened on 5 August 1839 and to the public on 12 August. The coaches were colour-coded: first class was bright yellow, second class blue and third class brown – while the through stock provided by the London and Birmingham Railway was buff and black.

When the Midland Counties Railway opened a more direct route from Rugby via Leicester on 1 July 1840, saving 10 miles, the BDJR attempted to alleviate competition by charging through first class passengers only 2s between Hampton and Derby – a quarter of the fare charged to local passengers. At one time the BDJR seriously proposed carrying London passengers free between Derby and Hampton rather than risk their travelling by Midland Counties. This uneconomic competition ended on 10 May 1844 when the BDJR, MCR and the North Midland Railway amalgamated to form the Midland Railway. It is interesting to record that Queen Victoria used the Hampton to Whitacre line on her visit to Chesterfield in 1843, being hauled over it by *Burton,* a 2-2-2 built by Messrs Tayleur and Company in 1839.

Meanwhile, on 10 February 1842 the BDJR opened a direct line from Whitacre Junction to Lawley Street, Birmingham, via Water Orton and Castle Bromwich. The service to London via Coleshill was retained and offered five Down and three Up trains daily, through coaches from Derby being worked onwards from Hampton by the LBR. On 11 April 1842 goods trains ceased running to Curzon Street, Birmingham, via Hampton and instead were directed over the new line to Lawley Street.

As the double tracked line between Whitacre and Hampton was not now fully utilised, an economy was made between August 1842 and March 1843 by singling it. At this period, the time interval system of signalling was in operation, but the branch was later worked by train staff without tickets. Even after the line was singled, two through coaches to London still ran over the line each way

until February 1845, when the only passenger trains were three each way from Whitacre to Hampton. This service was reduced to two in 1859, and from May 1877 became just a single coach morning train each way. This was a statutory 'Parliamentary' and had to be run. The branch passenger service for the day was over by 9.30 a.m. Although by 1902 the passenger train often ran without a single passenger, the service lingered on until 1 January 1917. Through goods traffic ceased on 24 April 1930, after which date the Hampton goods depot was treated as part of the ex-LNWR station.

The southern section of the branch was used as a siding for stabling wagons, access to this from the north being severed on 12 January 1935 when, about midway along the branch, a timber bridge over the River Blythe was certified as being too weak to support a train. The majority of the five river bridges were wooden. To prevent stock crossing the weak structure, a length of rail was lifted on either side. A local goods train still ran to Maxstoke until 30 April 1939, when this northern end of the line became a crippled wagon siding.

In the autumn of 1940, sandpits at Bannerley Common, 2½ miles north of Hampton, were enlarged in order to supply sand for the construction of RAF runways. Near Little Packington Bridge a concrete loading stage was built, to enable dumper trucks to tip sand into railway wagons. Great Bowden airfield was one of those that received sand from this source. Dispatched in three trains weekly, these were usually hauled by a Class 4F 0-6-0, but on at least one occasion was headed by a Class 5 4-6-0.

On 15 September 1942 another bridge over the River Blythe became unserviceable and wagons ceased to be stabled south of Maxstoke. Track on the central section of the branch was lifted in July and August 1953, the Hampton and Whitacre ends remaining as cripple sidings. For a short period a camping coach was placed at the Maxstoke end of the Whitacre siding.

On 1 November 1864 the original BDJR station at Whitacre closed and was replaced by a new one three-quarters of a mile south at the junction with the line to Nuneaton which opened concurrently. The Hampton branch passenger train used the outer face of the Down island platform. The construction of a goods yard for the new station caused the Hampton branch to be re-aligned for a quarter of a mile. Whitacre station closed on 4 March 1968 and has since been demolished. Lodge Crossing, protecting the lane leading to Maxstoke Castle, had its crossing keeper's lodge designed in a style that matched the castle.

The only intermediate station, Coleshill, was renamed Maxstoke on 9 July 1923 in order that Forge Mills on the Birmingham to Nuneaton main line could become Coleshill. Maxstoke station, built of brick in a domestic style of architecture, had no canopy over the platform which was shortened in due course to one coach in length. The station platform, as opposed to a halt, was one of the shortest in the country. The station booking office was without a date stamp which is indicative of the volume of traffic. An interesting feature of the station was that the signal levers were in the open beside the ballast. The track here had

inside keys. Maxstoke station building was demolished in the early 1960s as vandals had rendered it unsafe. Between Whitacre and Maxstoke signalling was block section and instruments, but between Maxstoke and Hampton there was no communication, not even by telephone.

An eight-wagon siding was put in 1½ miles north of Hampton on the east side of the line to serve Packington Hall Estate, traffic being coal inwards and timber outwards. It was disused by 1930.

The original station at Hampton was a joint BDJR/LBR passenger and goods station actually at the junction. In its early days Hampton Junction was very important because all traffic from London, Birmingham, Derby and the north passed through. The passenger station had three platforms, the centre serving the lines of the BDJR and the LBR. On 1 September 1884 the original LBR station closed and was replaced by a new structure a quarter of a mile distant on the Rugby side of the junction, though the MR continued to use its platform actually at the junction. Hampton was renamed Hampton Junction on 1 November 1849, reverted to Hampton on 1 December 1872 and the LNWR, but not the MR station, became Hampton-in-Arden on 1 July 1886.

At Hampton was the BDJR two-road locomotive shed, which was closed around 1842 and later used as Messrs Blackwell's saw mill. In the 'V' between the branch and main line were two detached houses erected by the BDJR and occupied by men who both became prominent railway personalities. Hampton's first station-master was James Allport, who combined this post with that of manager of the BDJR. He later became Sir James Allport, general manager of the Midland Railway. Vale House, the other dwelling, was occupied by the BDJR's engineer, Matthew Kirtley, who had been appointed locomotive foreman in 1839 at a salary of £200 per annum, under John Cass Birkinshaw, the company's engineer. Two years later, Kirtley, at the age of twenty-eight, became the BDJR's locomotive superintendent, and on the formation of the Midland Railway in 1844 was appointed locomotive superintendent of this much larger concern. A length of the former branch remained at the Hampton end until the early 1960s to give rail access to Messrs Blackwell's saw mill.

In 1887, the solitary train took thirty minutes each way for the 6½-mile trip, but a great acceleration was noted by 1910, when its journey was completed in fifteen minutes. In 1915, the branch passenger coach spent over twenty-three hours each day at Whitacre Junction. It was a six-wheel vehicle with a guard's and luggage compartment, smoking and ordinary compartment for each class. It left Whitacre at 8.10 a.m., arrived at Hampton at 8.25, and waited there until departure at 8.40, arriving back at Whitacre at 8.55 a.m. The 0-6-0 tender engine then worked the two goods trains, one only being worked when required. The day's work on the branch was over at 3.15 p.m. or at 11.50 a.m. when the conditional goods were not required.

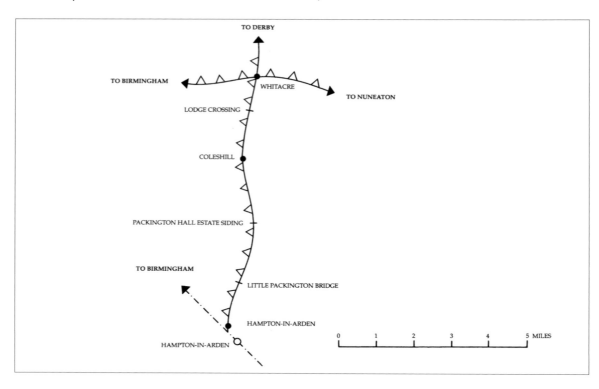

TO DERBY

TO BIRMINGHAM

WHITACRE

TO NUNEATON

LODGE CROSSING

COLESHILL

PACKINGTON HALL ESTATE SIDING

TO BIRMINGHAM

LITTLE PACKINGTON BRIDGE

HAMPTON-IN-ARDEN

HAMPTON-IN-ARDEN

0 1 2 3 4 5 MILES

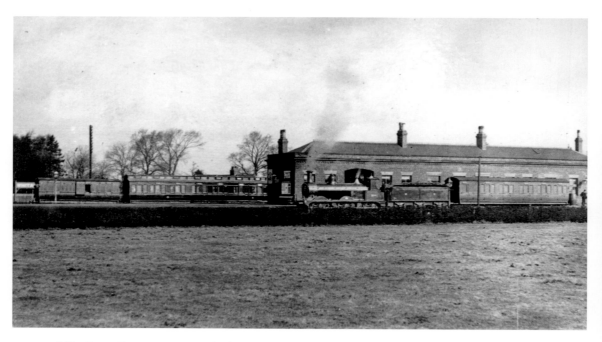

MR Class 2F 0-6-0 No. 2641 built in 1901, about to leave Whitacre Junction for Hampton-in-Arden, *c.* 1901, with its train of a single coach. The engine was re-numbered 3670 in 1907, and withdrawn in March 1930. A first class clerestory coach of a Down main line train can be seen on the left of the station building. *Author's collection*

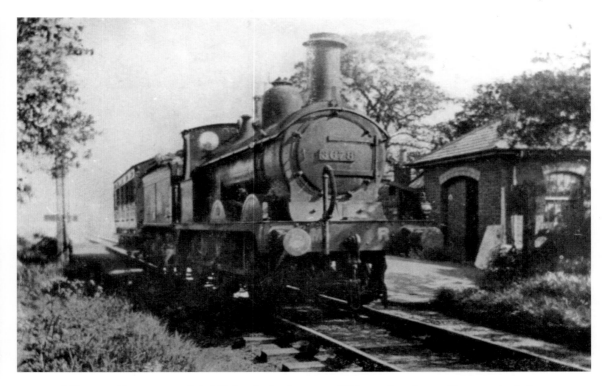

MR 0-6-0 No. 3678 at Coleshill, heads the 8.10 a.m. Whitacre Junction to Hampton-in-Arden, May 1916. The headlamp seems to be in an unorthodox position. No. 3678, as 43678, was withdrawn in December 1959. *A. Cocking*

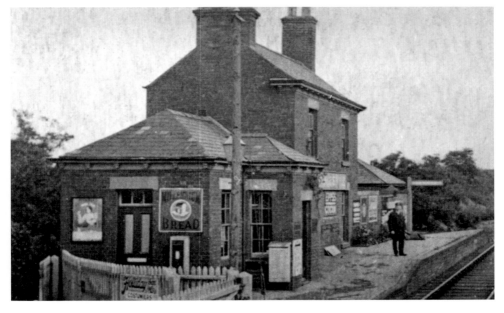

Coleshill showing a plentiful supply of advertisements, view towards Hampton-in-Arden. The platform is only about the length of one coach. *Author's collection*

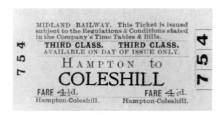

One of the rarest tickets issued in the British Isles.

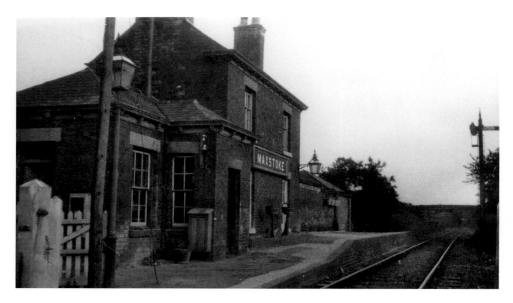

A post-1923 view of Coleshill station after being re-named Maxstoke. As passenger trains had ceased, advertisements have been removed. Notice the row of fire buckets hanging on the side of the end building. *Author's collection*

A Whitacre Junction to Hampton-in-Arden goods train near Packington, 1901. *Author's collection*

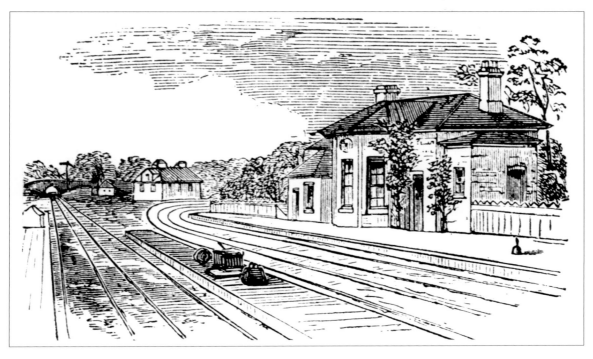

Hampton Junction in 1866, before the removal of the LNWR platforms. The line to Whitacre Junction curves away on the right. *Author's collection*

Hampton Junction, *c.* 1960. *Lens of Sutton*

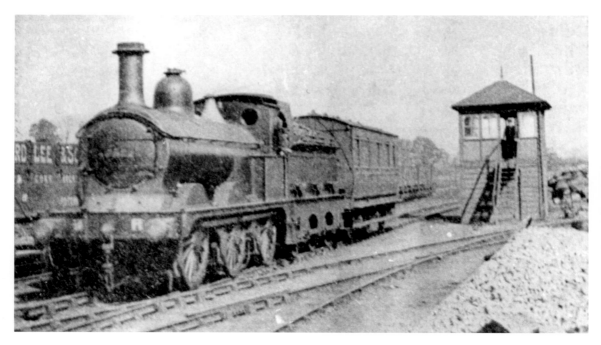

An MR 0-6-0 heads the Whitacre Junction train away from Hampton-in-Arden, *c.* 1901. Notice the tender cab which was not fitted to all of the class. *Author's collection*

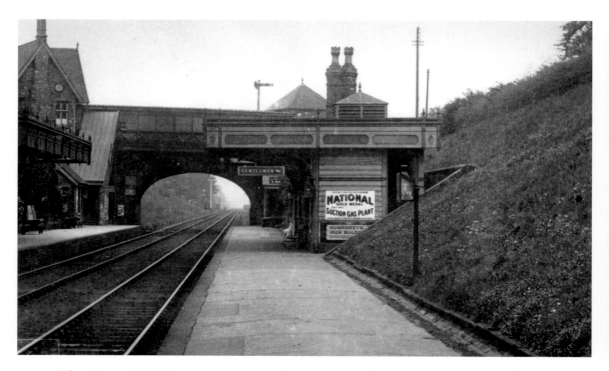

The 1884 ex-LNWR Hampton-in-Arden station in pre-nationalisation days. The platform oil lamps are set at a height making them easy to light. *Author's collection*

Monument Lane to Harborne

The Harborne Railway was authorised by Act of 28 June 1866 to construct a line from the LNWR at Monument Lane to Harborne, a distance of about 2½ miles, but it was more than another three years before construction commenced.

The single line opened on 10 August 1874, the LNWR working the line for 50 per cent of the gross receipts. In its early days passenger traffic was light, only six trains each way on weekdays and three on Sundays, but by August 1887 large housing developments had led to twenty trains on weekdays only, most Down trains taking thirteen minutes and Up trains sixteen minutes. It was an early example of a regular interval service timetable, most trains leaving Harborne at forty-five minutes past the hour and many trains to Harborne leaving Birmingham New Street at fifteen minutes past. No passenger service ran on the branch on Sundays.

By April 1910 the service had increased to thirty Down and thirty-one Up, some of the former running non-stop from New Street to Rotton Park Road, reducing the New Street to Harborne time from sixteen minutes to thirteen minutes. This fast service was also provided at lunchtime to enable workers in the centre of Birmingham to return home for their midday meal. The effect of bus competition was felt by July 1922, when only twenty-one Down and twenty Up trains were offered. One unfortunate practice was keeping an Up branch train waiting at Icknield Port Road if a main line train was late. It was a profitable branch – the best in Birmingham – and three times the company refused the LNWR's offer of purchase. It was merged in the LMSR upon Grouping in 1923.

Despite a competitive day return fare of 3d from Harborne to New Street and a weekly third class season for 2s, declining traffic caused the passenger service to be withdrawn on 26 November 1934. The last train was the 11.08 p.m. from Birmingham hauled by ex-LNWR Class 2F 0-6-2T Coal Tank No. 7742, its passengers partially consoled by the announcement that the 'Corporation is putting additional buses on the routes concerned'. During the Second World War, the suggestion was not adopted that the branch be reopened to passenger traffic using push-pull trains and calling intermediately only at Rotton Park Road and Hagley Road, in particular missing Monument Lane where much time used to be spent collecting Birmingham tickets.

Icknield Port Road and Rotton Park Road had no goods facilities, but a spur ran from Rotton Park Road station to Mitchell and Butler's Cape Hill Brewery, which provided regular traffic and had a main line about 1,000 yards in length laid by Messrs Gowing and Ingram in 1904-06. The brewery owned three outside cylinder 0-4-0STs and an 0-4-0 Aveling and Porter geared tank engine. Rail traffic to the brewery ceased on 31 March 1962.

The Harborne branch itself closed to goods on 4 November 1963, Harborne station being taken over by Chad Valley Toys and some land used for building houses. The Harborne Line Walkway was opened in 1981 from Selwyn Road Bridge, north of Rotton Park station, to Park Hill Road, just north of the site of Harborne station. In the early 1930s, principal locomotive types used on the branch were 0-6-0s, 2-4-2Ts, 0-6-2Ts and Fowler 2-6-2Ts. The LNWR did not use steam railmotors on the branch, probably because they were unsuited to the very heavy passenger traffic. In the early years of this century, crowded eight-coach trains of six and eight wheel stock were the norm, but by the 1930s had dwindled to four coach bogie sets. Until the LNWR abolished second class in 1912, notices were displayed on platforms indicating platform areas where the various classes of coach would stop. This was fine until a set worked over the Soho Road Loop and was therefore reversed, placing the coaches in the wrong position.

After leaving the main line, the branch rose on a gradient of 1 in 66 and curved sharply south-west to cross the Birmingham and Wolverhampton Canal by a girder bridge, and for almost the remainder of its length was in a steep-sided cutting. The branch had fourteen bridges, all except two being overline. The first station was Icknield Port Road. Initially, it was situated between two overbridges and in consequence had a very short platform, quite inadequate when the service demanded longer trains. In 1897, it was replaced by a new station with a longer platform on the Harborne side of Icknield Port Road Bridge. The station became unremunerative and was closed on 18 May 1931.

The line continued climbing at 1 in 66 to Rotton Park Road station, in 1903 it was converted to an island platform so that a passing loop could be installed. A ground frame on the platform acted as an intermediate box between Harborne Junction and Harborne. The gradient eased to 1 in 224 through the station, but beyond the 1 in 66 continued to the single platform at Hagley Road, a small goods yard and coal wharf being sited on the Birmingham side. Immediately south of the station the line descended at 1 in 66 to Harborne, after a quarter of a mile crossing the Chad Valley on a high embankment. Harborne had a single platform but, unlike the others, was on the left side of a Down train. In 1901, a second platform was built alongside the run-round loop, but was rarely, if ever, used. It had no physical connection with the existing platform, which was extended in 1911, the year the redundant second platform was removed and replaced with additional sidings. In 1908, to encourage passengers, a footbridge was opened from the station across to the newly developed Harborne Estates. The turntable at Harborne was removed in 1942 and a sand wharf built on its site.

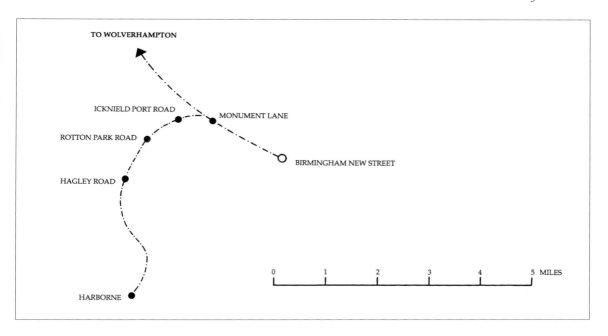

TO WOLVERHAMPTON

ICKNIELD PORT ROAD

MONUMENT LANE

ROTTON PARK ROAD

BIRMINGHAM NEW STREET

HAGLEY ROAD

0 1 2 3 4 5 MILES

HARBORNE

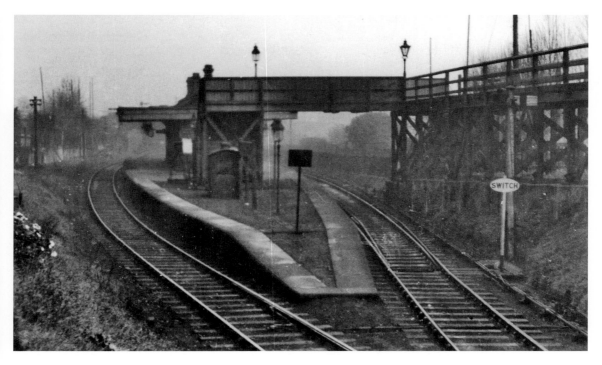

Rotton Park Road, originally a single-track station, was converted to an island platform in 1901. Notice the raised wooden walkway and bridge giving access to the platform. The switch point, right, was sprung open by vehicles travelling in the correct direction, but would de-rail and halt any vehicles running away backwards. *Lens of Sutton*

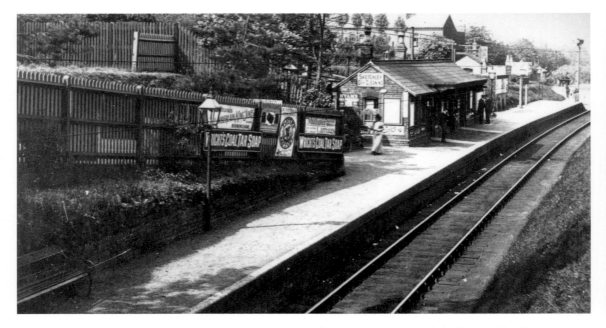

Hagley Road, view towards Birmingham, *c.* 1905. The station is a low, brick-built, slated building. The lady carries a parasol. There is a wide variety of enamel advertising plates for soap, bedsteads, cigarettes, carriages, dry cleaning, ink and rubber heels. *Author's collection*

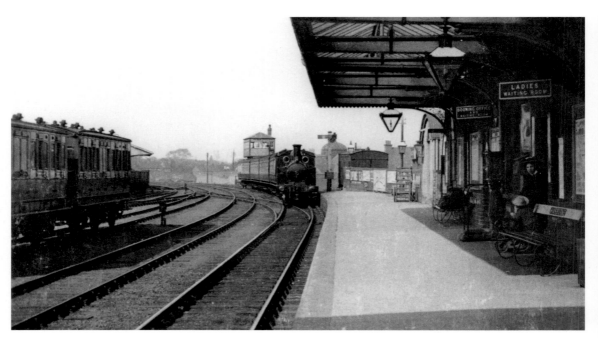

A four-coach train arrives at Harborne in 1911, the station name appearing on the seat back. A horse box stands to the right of the engine. Notice the glazing in the platform canopy producing a rather lighter and more airy appearance, the tall signal box giving a splendid view of the station, and the spare coaches, left. *Author's collection*

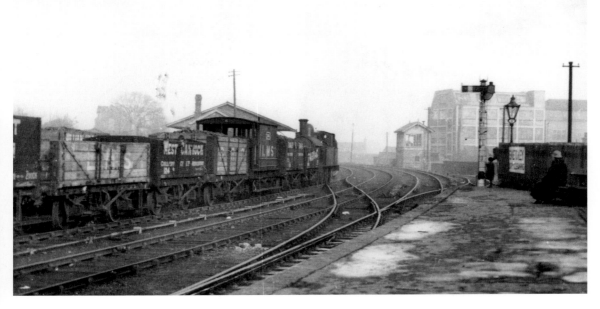

An ex-LNWR 0-6-2T shunts at Harborne, *c.* 1930. The brake van is of the six-wheel type. Quite a variety of private owners' wagons can be seen. The tall signal box in the 1911 view on page 32, has been replaced. The seated lady is warmly dressed. *Lens of Sutton*

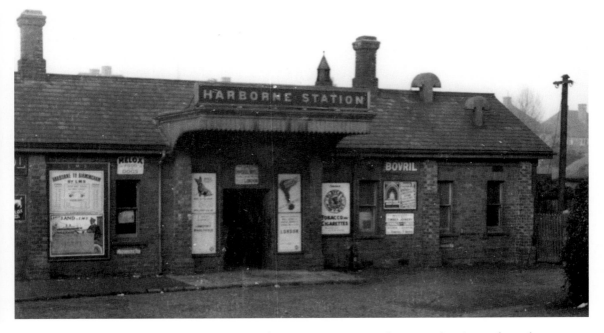

The plain and uninviting entrance to Harborne station, *c.* 1930. A poster advertises a cheap day return ticket Harborne to Birimingham for *6d* first class and *3d* third. The two types of ventilator on the roof are worth a second glance. *Lens of Sutton*

Kenilworth to Berkswell

The line from Kenilworth to Berkswell, authorised by an Act of 18 July 1881, linked the London and Birmingham Railway with the Coventry to Warwick and Leamington branch, allowing trains to run direct from Birmingham to Leamington. As well as offering a shorter route it had the additional advantage of easing some of the congestion at Coventry. The branch between Kenilworth and Berkswell opened to goods traffic on 2 March 1884 and to passengers on 2 June with an initial service of six Down and seven Up trains on weekdays only. The line was closed completely when the regular passenger service was withdrawn on 18 January 1965. The junction at Berkswell was soon removed to eliminate a 95 mph limit on the Up line, the rest of the branch being lifted also in 1965, except for a short length retained at Berkswell. This was a Down Refuge Siding occasionally used for stabling the Royal Train.

The LBR station at Berkswell originally had its platforms staggered north and south of the level crossing, but they were eventually placed adjacent to each other north of the crossing. The station has had quite a number of name changes. Originally called Docker's Lane, it became Berkswell on 1 January 1853, and Berkswell and Balsall Common on 1 February 1928. Berkswell still remains open, but Kenilworth closed completely on 18 January 1965, goods traffic having been withdrawn two weeks previously.

Opposite: Two-car Gloucester Railway Carriage & Wagon Works DMU taking the Berkswell Direct line at Kenilworth Junction, 23 July 1961. Running as the 9.30 a.m. Northampton to Birmingham New Street, it has been diverted due to pre-electrification works between Coventry and Berkswell. *Michael Mensing*

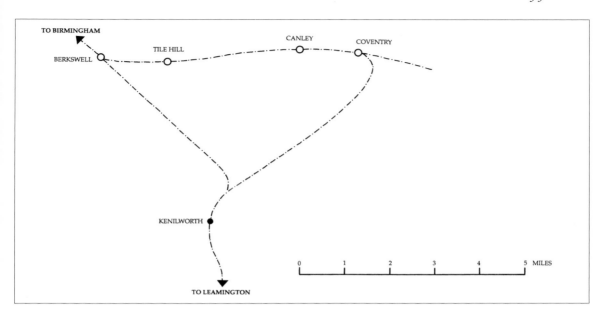

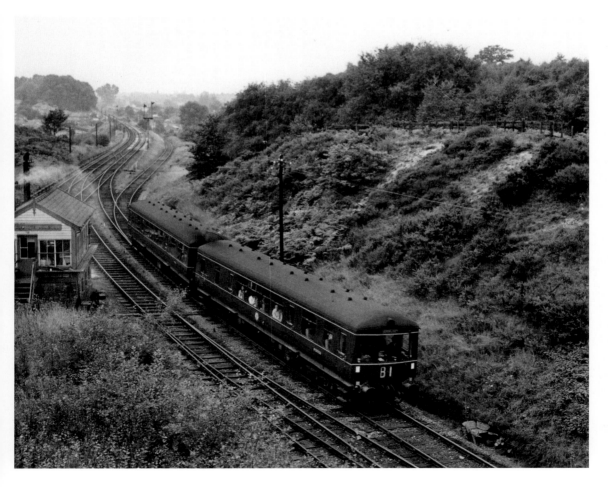

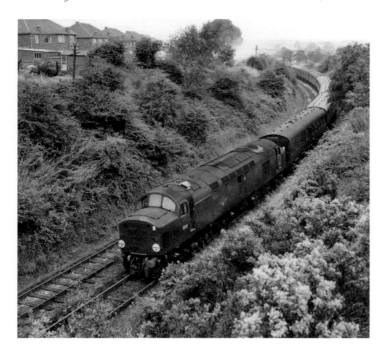

English Electric type 4 1Co-Co1 diesel-electric D317 coming off the Berkswell Direct line at Kenilworth Junction, 23 July 1961, with the 9.40 a.m. Wolverhampton High Level to Euston, diverted due to pre-electrification works. *Michael Mensing*

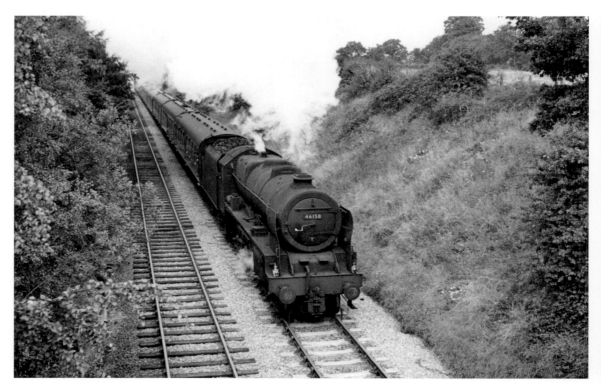

Rebuilt Royal Scot class 4-6-0 46158 *The Loyal Regiment* (21C Bushbury), east of Berkswell, 4 September 1960, with the diverted 9.40 a.m. Wolverhampton Low Level to Euston. *Michael Mensing*

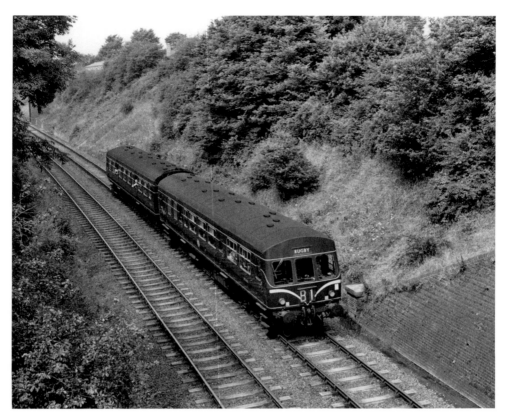

A two-car Gloucester Railway Carriage & Wagon Works DMU, Motor Brake Second M50356 leading, working the diverted 12.35 p.m. Rugby Midland to Birmingham New Street. It is seen here at Kenilworth Junction, 23 July 1961, taking the Berkswell Direct line. *Michael Mensing*

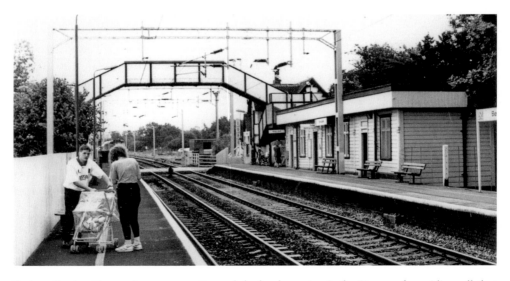

Berkswell, view Up, 14 August 1993. Beyond the level crossing is the Down refuge siding, all that remained of the Berkswell Direct line. *Author*

Coventry to Nuneaton

From the London and Birmingham Railway at Coventry one branch ran northwards to Nuneaton and south to Warwick. On 18 June 1842, the Warwick and Leamington Union Railway received an Act to build a line from Coventry to Warwick. This undertaking was taken over by the London & Birmingham Railway on 3 April 1843 and opened on 9 December 1844. On 3 August 1846 the Coventry to Nuneaton line was authorised, and opened on 12 September 1850 – tapping colliery traffic en route.

As a result of the dramatic collapse of twenty-three arches of the Spon End Viaduct at Coventry on 26 January 1857, the section from Coventry to Coundon Road was closed for nearly three years while restoration was carried out. An Additional Powers Act of 23 July 1859 was obtained in order to authorise its reconstruction as an embankment and viaduct. The line was eventually reopened on 1 October 1860.

The Nuneaton and Hinckley Railway Act of 14 June 1860 granted to the LNWR running powers over the MR's Rugby to Leicester line for all traffic, and in return the MR could run over the LNWR's Coventry to Leicester line. The MR exercised these powers when it began working a goods train from Nuneaton to Coventry on 1 September 1865. Immediately, or almost so, the MR built its own locomotive shed at Coventry. This was situated at the north end of the station and was used for stabling its shunting engine. The occupant for many years was a Kirtley 0-6-0 outshedded from Leicester. Although the shed closed in 1904, the building was not demolished until 1959.

Daimler Halt, serving the BSA/Lanchester/Daimler Works and opened on 12 March 1917, was mainly used by car workers. Longford and Exhall station closed to passengers on 23 May 1949, and passenger traffic over the whole line was withdrawn on 18 January 1965. A large oil depot opened south of Bedworth, handling trains from the major refineries.

The line reopened to through passengers on 2 May 1977, and a service was reintroduced between Coventry and Nuneaton on 11 May 1987. On 16 May 1988 a new Bedworth station was opened with bus stop type shelters and platforms just long enough for a two car set. Meanwhile the Coventry to Leamington line was singled from 7 December 1972, a crossing loop being provided at Kenilworth.

The initial train service between Coventry and Nuneaton gave seven trains each way on weekdays and two on Sundays, while the number on weekdays had risen to ten by 1887. In April 1910, thirteen Down and eleven Up trains were shown, and two on Sundays, while by July 1938 fifteen ran on weekdays and no fewer than ten on Sundays. In 2011, the service offers sixteen on weekdays and six on Sundays. On 1 October 1908 a service of through trains was inaugurated over the branch from Leamington, through Leicester to Nottingham. One set of coaches was provided by the LNWR and the other by the MR.

In January and February 1932, the LMS tested a Michelin pneumatic-tyred railcar on the Bletchley to Oxford line. It proved a partial success and a tripartate agreement was made between the LMS, Michelin and Armstrong-Siddeley Motor Co. for the latter to construct two railcars at Coventry. A lightweight body was required, hence the involvement of Messrs Armstrong which manufactured aircraft as well as cars. To spread the weight, two eight-wheel bogies were used making the weight on a single tyre of just over half a ton. The weight of the railcar in working order was 6¼ tons and with payload, about 10½ tons. It was carried on two eight-wheel bogies of light construction. Each wheel had a pneumatic tyre fitted with a pressure gauge, and if the air fell below a set pressure a hooter was sounded in the driver's cab. As a safety precaution, if a tyre deflated, the outer cover pressed against a solid tyre, which was part of the inner tube. This meant that the tyre need not be changed immediately. One of the bogies was driven through mechanical transmission by a V12 275-hp Armstrong Siddeley engine with a weight of only 1000 lb. Successful at first, crankcase trouble developed and one railcar had a Hispano Suiza engine substituted. Maximum speed was 66 mph and its running was quiet and steady. The first car was completed on 20 June 1936, and as the factory had no siding, it was transported half a mile by road to Coventry Goods Yard. Numbered '1' or '2', 'Coventry Railcar' was inscribed on the body sides. The trailing bogie had four slippers for track circuiting. The driver was placed in a raised conning tower above the engine and had a good view in both directions, so at the end of the journey there was no need to turn the car or provide duplicate controls. Forty-eight seats were provided in the main compartment with eight folding seats in the luggage compartment.

A press run was made on 28 July 1936, and it came into service on 14 September 1936; interestingly it was extra to the public timetable and subject to cancellation at any time. Riding was described as superb, being almost completely silent and smooth. Light construction and rubber adhesion meant that 50 mph could be achieved in about 30 seconds, or 900 yards, and could be brought to a stand from 50 mph in 9 seconds, or 250 yards. Although liked by the public, railway officials displayed a lack of enthusiasm, perhaps due to its inability to handle tail traffic. One member of the public believed they were not above criticism and wrote to the LMS complaining that its engineers had been playing up and down the line to Leamington with a new-fangled toy and

blowing its two-tone horn, which led to his excited horses believing they were going out hunting. In late 1937, the two railcars were returned to Michelin's Stoke-on-Trent works where they remained until broken up in 1945.

To avoid trains from Nuneaton to Rugby passing through the congested Coventry station, an avoiding line was constructed by Messrs Holme and King Ltd to divert most of the mineral traffic. Powers for building this freight-only, double-tracked, 3½-mile-long loop line from Humber Road Junction on the main line to Three Spires Junction on the Nuneaton line were granted by Parliament on 26 July 1907, the line being opened on 10 August 1914, a week after the outbreak of the First World War. Public goods depots were provided at Gosford Green and Bell Green. Morris Motors Ltd's Courthouse Green Works just south of Bell Green was served by rail, most of the company's locomotives having four wheels and either petrol, or diesel mechanical drive. In 1961, the company ceased to operate locomotives at the works.

The Humber Road Junction to Gosford Green goods section of the Coventry Loop Line closed on 7 October 1963, prior to electrification of the main line, while the connection with the Royal Naval stores depot was removed on 26 February 1967. In 1970, a car delivery firm opened a rail-served depot at Gosford Green, double-deck wagons delivering 200 cars to Johnstone in Renfrew and returning with Scottish-built vehicles. Bell Green yard, closed to general traffic on 5 July 1965, also developed car traffic. Use of the line declined, however, and the truncated loop line from Gosford Green to Three Spires Junction closed on 8 April 1972.

Another important industrial branch was the Foleshill Railway, constructed by Cruwys and Hobrough and opened in 1901. It ran from Webster's Sidings, a mile north of Coundon Road station, in a south-westerly direction to Webster's Brickworks. The following year the line was extended to the Coventry Ordnance Works, crossing the 3 ft 6 in gauge Coventry Corporation Tramways at Stoney Stanton Road on the level. The Ordnance Works purchased its first locomotive in 1906 and worked over the Foleshill Railway to the LNWR exchange sidings; heavy naval guns caused some difficulties when travelling over the steep gradients and curves, requiring the Ordnance Works engine to be assisted by one from the Foleshill Railway. The Foleshill Railway Ltd officially took over the line from Webster's Brickworks on 12 August 1915.

Following the opening of the Coventry Loop Line in 1914, the Ordnance Works tended to use this route to which it had access, rather than the Foleshill Railway. Although it was now possible to run through from the Loop Line to the Foleshill Railway, the option was never taken. The Ordnance Works closed in around 1926, and reopened in 1938. In 1945, the Foleshill line was cut at Stoney Stanton Road and the Ordnance factory end of the line taken over by the Royal Navy. The Ordnance Works closed on 4 March 1967, and the rail link was removed.

In 1905, a branch of the Foleshill Railway served Messrs Courtauld's new factory, and on 10 November 1921 the Foleshill Railway became the property

of Courtaulds Ltd. On 29 February 1972 Messrs Courtauld's boilers were scheduled to change from being coal-fired to natural gas, but due to a miners' strike traffic ceased, and the line closed a few days earlier than anticipated.

These engines worked regularly on the Foleshill Railway:

Name	Wheel arrangement	Builder	Works No.	Year built	Working on line
Rosabel	0-4-0ST	Hawthorn, Leslie	2491	1901	1901–23
Progress	0-4-0ST	Peckett	1611	1923	1923–52
Rocket	0-4-0ST	Peckett	1722	1926	1926–72
–	0-4-0ST	Peckett	2085	1948	1964–72
–	4-wheel	Sentinel	9596	1955	1958–65
–	0-4-0 petrol	Baguley Cars	1442	1925	1925–43

From Three Spires Junction a 2-mile-long line runs to the Homefire Plant. NCB locomotives were used which from 1965, to obviate smoke nuisance, were of the diesel variety. In 1991, Wilmott Brothers (Plant Services) Ltd took over operation of the line, using some British Coal locomotives and some of their own machines. The modernised line now serves ProLogis Park, a 265-acre industrial and distribution site.

A further feeder to the Coventry to Nuneaton line was a mineral branch built by the LNWR around 1862 from just south of Hawkesbury Lane station to Wyken Main Colliery. About twenty-five years later the line was extended to Alexandra Colliery, making a total length of about 2 miles. The branch was lifted in 1928, except for a length of approximately half a mile at the Hawkesbury Lane end, used by trains to and from Longford Power Station between March 1929 and April 1967.

The other principal industrial branch serving the Coventry to Nuneaton line was that to Griff Colliery on the western outskirts of Nuneaton. The line, authorised on 28 June 1877, opened on 22 June 1881. It was worked mostly with 0-6-0Ts or 0-6-0STs from locomotive sheds at Clara, No. 4 Colliery and Griff Pumping Shaft. The colliery's first engine was an 0-4-2ST built by Bury, Curtiss and Kennedy in around 1840 and sold to the Shropshire and Montgomeryshire Railway in 1911. MR engines commenced working over the LNWR's Griff branch on 11 September 1889. A mile-long extension of the branch led to Stanley's Brick Siding. The Griff branch closed on 31 January 1965.

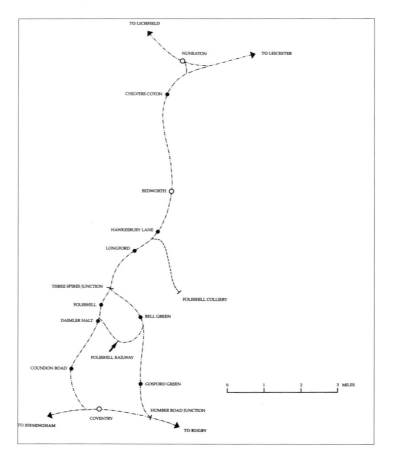

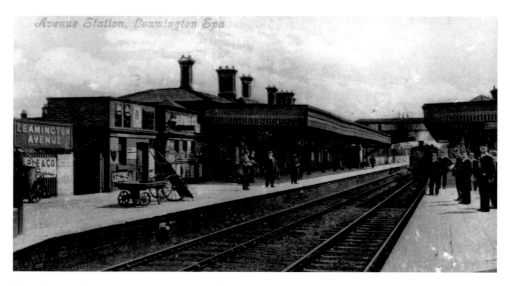

Leamington (Avenue) station, view towards Rugby, *c.* 1910. A stopping passenger train is entering, but passengers are more interested in the photographer. Notice the luggage barrows of the period and the sagging platform canopy. *Author's collection*

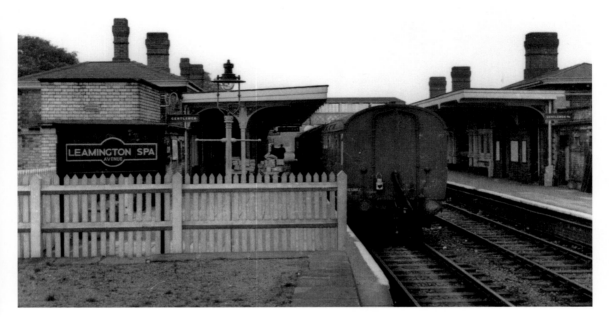

Leamington Spa (Avenue), view towards Rugby, *c.* 1960. The replacement canopy has most attractive supports. The parcel trolleys are of more modern design than those in the view on page 42. *Lens of Sutton*

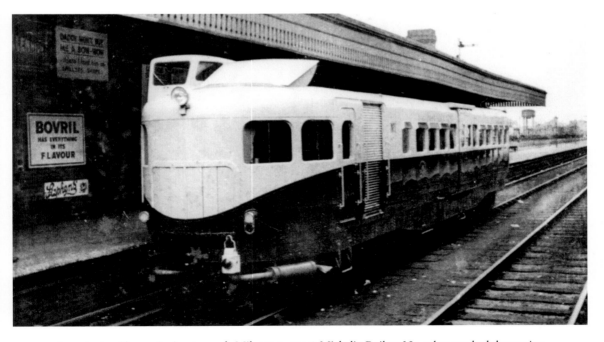

Leamington (Avenue), view towards Milverton, 1936. Michelin Railcar No. 1 has worked the service from Coventry. The emblem on its side reads: 'Coventry Railcar'. Notice the raised driver's cab, also one of Bovril's humorous advertisements: 'Bovril has everything in its flavour,' while above is a poster with the wording of a popular song: 'Daddy won't buy me a bow-wow'. *Author's collection*

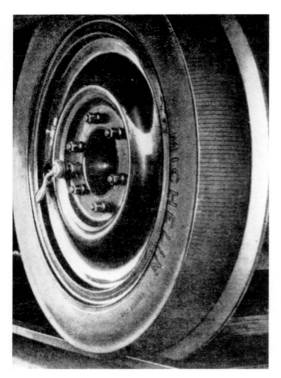

Left: Pneumatic tyre of the Michelin railcar, showing the steel flange to keep it on the rails. *Author's collection*

Below: A Birmingham Railway Carriage & Wagon Works DMU backing into the Down platform at Leamington Spa (Avenue), 24 June 1961, to form the 4.15 p.m. to Nuneaton (Trent Valley). Notice that part of the platform is of timber. *Michael Mensing*

A train arriving at Foleshill, *c.* 1910. *Author's collection*

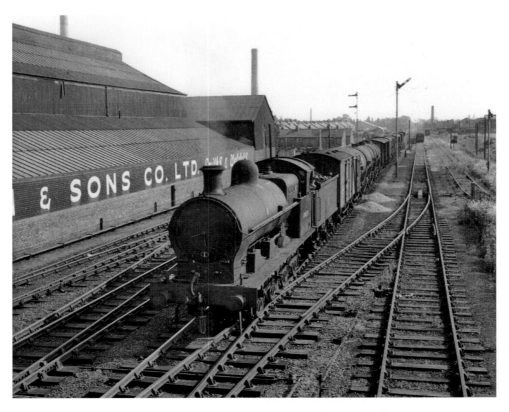

Ex-LNWR G1 Class 7F 0-8-0 No. 49439 (2B Nuneaton) approaching Foleshill station, 24 June 1961, with a Down mixed freight. No. 49439 was withdrawn in December 1962. *Michael Mensing*

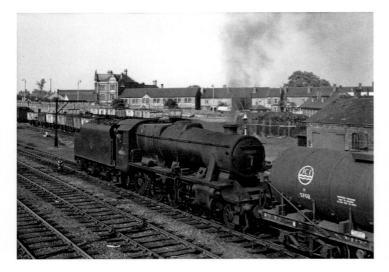

Class 8F 2-8-0 No. 48686 (2B Nuneaton) built at Brighton during the Second World War by the SR, moving a Down freight from a siding south of Foleshill, 24 June 1961. No. 48686 was withdrawn in November 1966 from Stockport. *Michael Mensing*

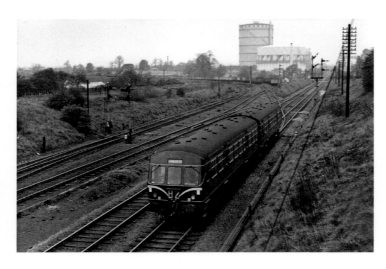

A two-car Metro-Cammell DMU working the 1.05 p.m. Leamington Spa (Avenue) to Nuneaton (Trent Valley) passes Three Spires Junction, 16 April 1961. *Michael Mensing*

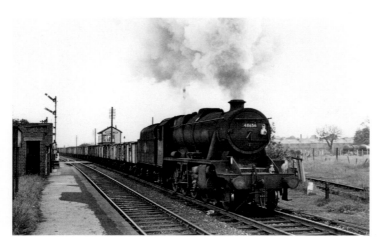

Class 8F 2-8-0 No. 48656 (1E, Bletchley), built by the SR at Eastleigh, passes Hawkesbury Lane with a Down coal train, 10 October 1964. The lamp bracket formerly at the top of the smokebox has been placed in a lower position to prevent the fireman from being electrocuted by overhead wires. No. 48656 was withdrawn in August 1965 from Mold Junction. *Michael Mensing*

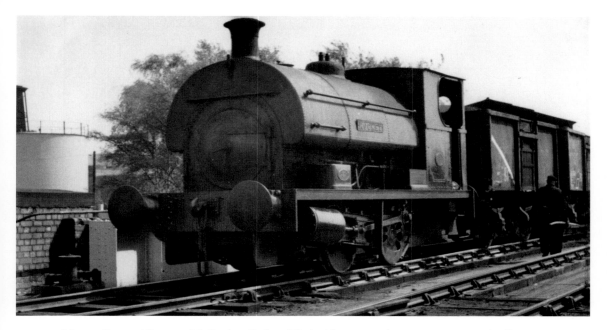

Messrs Courtauld's 0-4-0ST *Rocket*, Peckett Works No. 1722 of 1926, seen on 26 April 1968. *Revd Alan Newman*

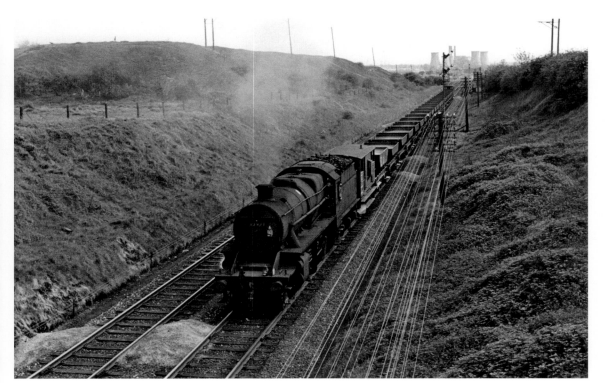

Stanier Class 5 2-6-0 No. 42981 approaches Bedworth with a train of Down permanent way 'Catfish' ballast wagons, 12 May 1964. *Michael Mensing*

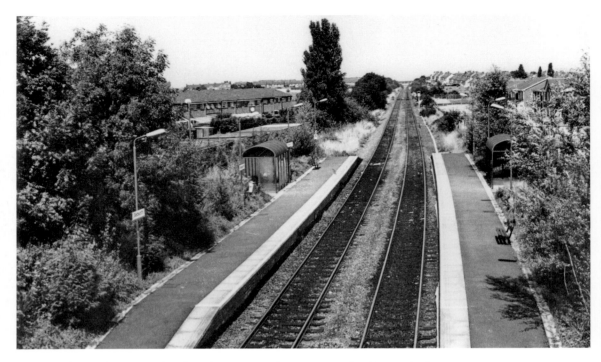

The newly re-opened Bedworth station, 14 August 1993, view Down. *Author*

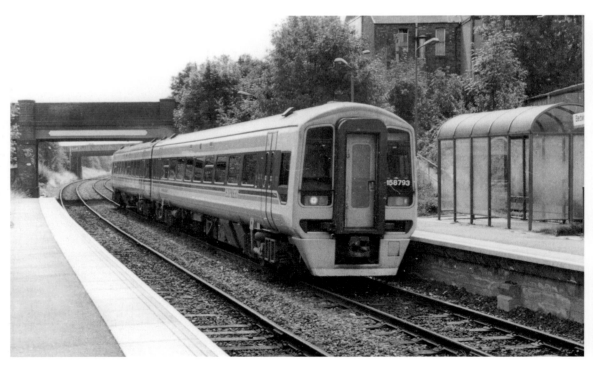

DMU 158793 arrives at Bedworth with the 12.57 Coventry to Cambridge, 14 August 1993. *Author*

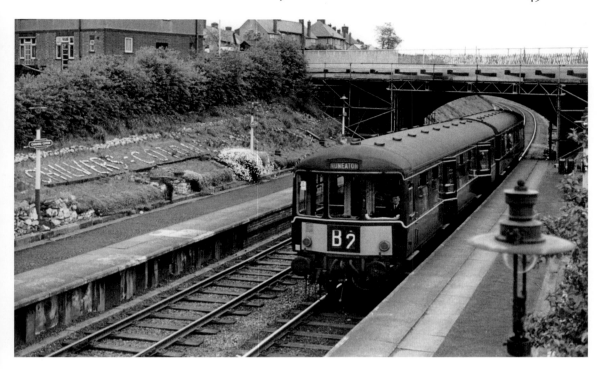

A two-car Birmingham Railway Carriage & Wagon DMU arrives at Chilvers Coton with the 17.28 Leamington Spa (Avenue) to Nuneaton (Trent Valley), 12 May 1964. Notice the gas lamp in the right foreground. *Michael Mensing*

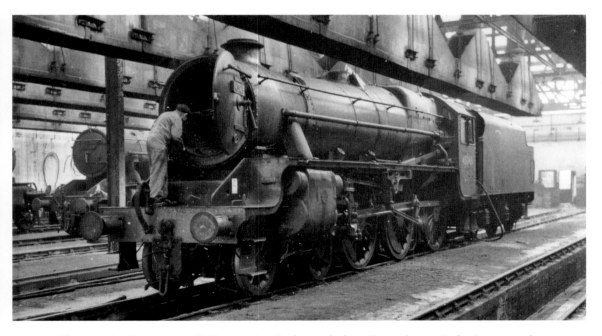

Class 5 4-6-0 No. 45065 (5E Nuneaton) at its home shed, 13 September 1965, having its smoke box ash removed. Notice the chutes to extract the smoke. *Revd Alan Newman*

Rugby to Leamington and Warwick

The Rugby and Leamington Railway, authorised on 13 August 1846, was purchased by the LNWR on 17 November 1846. In 1848 Lord Lifford, an LNWR shareholder, asked the Chairman, G. C. Glyn, whether the line would pay when completed, and was told it was unlikely. Construction work ceased but, under pressure from Warwick, resumed early in 1850. The principal engineering work was Offchurch Viaduct west of Leamington, which spanned both the Warwick and Napton Canal and the River Leam.

The single line opened on 1 March 1851 with intermediate stations at Marton and Birdingbury, while Dunchurch was opened to passengers on 2 October 1871 and to goods on 1 February 1872. Traffic developed sufficiently to warrant doubling the line between Rugby and Dunchurch on 27 March 1882, while on 28 January 1884 a second track from Marton to Leamington was brought into use.

The Rugby to Leamington stopping passenger service was withdrawn on 15 June 1959, the last train being worked by Ivatt Class 2 2-6-2T No. 41227. This was not the end of passenger trains over the branch as on some Sundays during the summer of 1960, lines between Coventry and Rugby were completely closed for engineering work in connection with electrification, and the Leamington to Rugby branch was used as a diversion. Dunchurch shut to goods on 2 November 1964, while Birdingbury had closed on 3 August 1953 and Marton on 3 July 1961. As Southam and Long Itchington on the Daventry line remained open for traffic, the section between Leamington and Marton Junction was kept open for freight until 4 April 1966. From this date until complete closure of the line on 1 August 1985 cement trains only gained access to the branch from Rugby. Some stations on the branch were subject to quite a number of name changes. On 1 July 1853 Marton was renamed Marton for Southam, in October 1860 changed back to Marton, in January 1877 reverted to Marton for Southam and on 1 August 1895 altered yet again to Marton – the line from Daventry to Marton Junction having opened on this last date. Discounting the Stratford-upon-Avon and Midland Junction Railway, the 6½ miles from Marton to Leamington was the longest stretch of line in Warwickshire without a station, the average distance between stations in the county being 2.88 miles.

Because of opposing pressure from Warwick and Leamington, Avenue station had five name changes and Milverton no fewer than eight. Leamington Spa (Avenue) station stood back to back with the GWR station and connected with it. The first station at Avenue Road, little more than a wooden shed, was replaced by a new brick-built station in Italian style, this being completed in March 1860. It closed on 18 January 1965 as did Milverton, which was timber-built to give a light construction, necessary because of its position on an embankment.

The timetables showed little variation, except for running times growing progressively longer until the 1930s. In August 1887, seven Down and eight Up trains ran daily, taking about thirty-six minutes to cover the distance of 15¾ miles. Between July 1908 and December 1912 a train carried a through coach from the 6.55 p.m. Euston to Leamington, which had been slipped at Rugby. By April 1910 nine stopping trains ran each way, taking about forty minutes, while in July 1922 eleven trains were run taking about forty-three minutes. One Down train carried a through coach from Euston to Warwick. In July 1938, ten Down and eleven Up trains were run on weekdays, taking about thirty-three minutes, while by this date Sunday trains had been introduced, seven running each way.

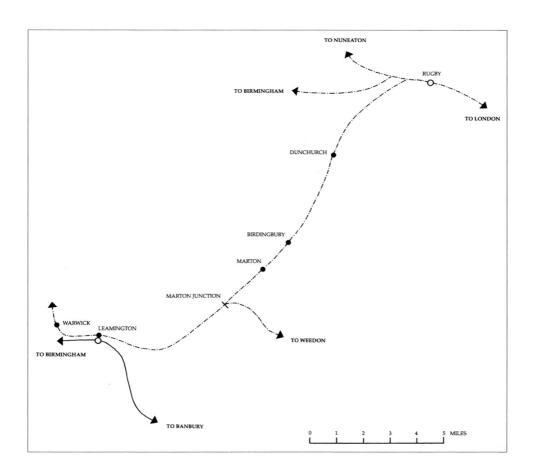

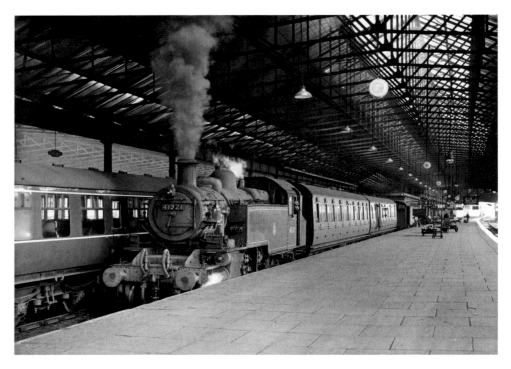

Ivatt Class 2 2-6-2T No. 41321 (2C Warwick) waiting at Rugby, 29 April 1958, with the 2.45 p.m. to Leamington Spa (Milverton). No. 41321 was withdrawn in July 1965 from Exmouth Junction shed. *Michael Mensing*

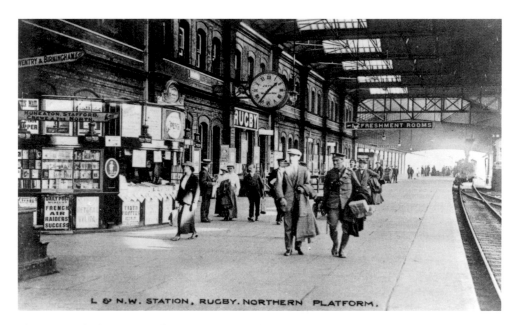

The Down platform at Rugby, *c.* 1916. A *Daily Post* placard announces: 'French Air Raiders Success.' The finger-board, left, points to 'Nuneaton, Stafford, Crewe & the North', while another to 'Coventry & Birmingham'. *Author's collection*

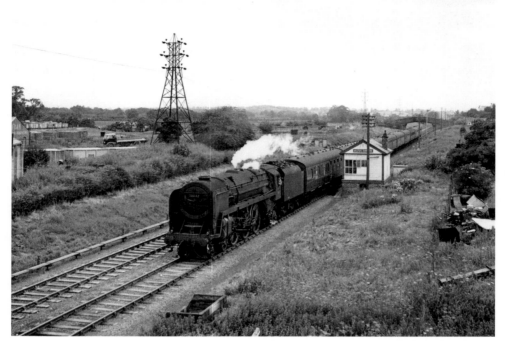

BR Standard Britannia class 4-6-2 No. 70047, unnamed, passes Bilton Sidings signal box, 26 June 1960, leaving Rugby for Leamington with the 10.30 a.m. Euston to Wolverhampton (Low Level). It was diverted due to pre-electrification works. *Michael Mensing*

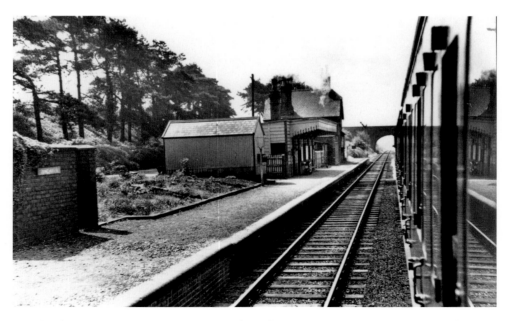

Dunchurch, view west, 16 May 1959. Apart from the stationmaster's house, the principal station buildings are of timber. The name board on the brick structure, left, is almost indecipherable. The notch in the platform edge suggests that the platform has been extended. *E. Wilmshurst*

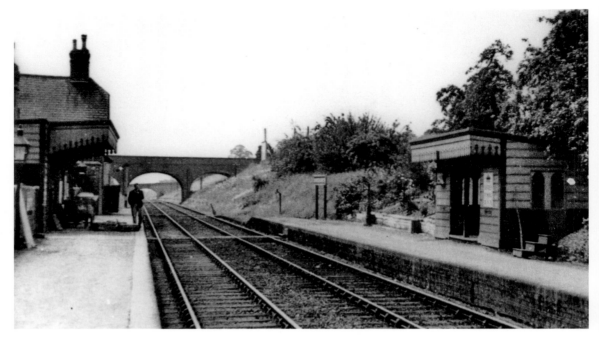

Dunchurch, view towards Leamington, *c.* 1920. *Author's collection*

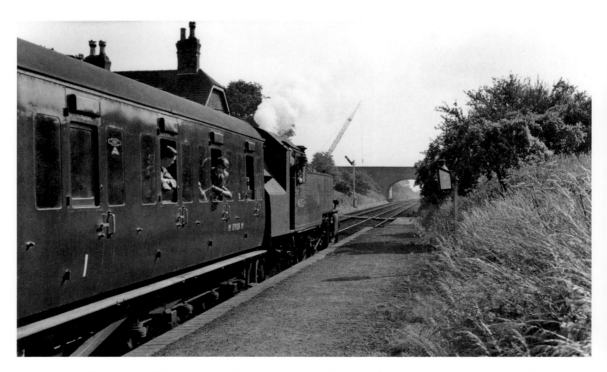

Ivatt Class 2 2-6-2T No. 41227 at Dunchurch with a full head of steam, waits departure propelling the 4.30 p.m. Leamington Spa (Milverton) to Rugby on 13 June 1959, the last day of passenger service. *Michael Mensing*

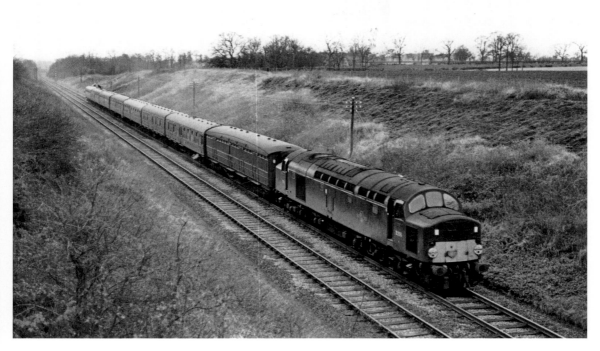

English Electric Type 3 1Co-Co1 D255 approaches the site of Dunchurch station with the diverted 10.13 Birmingham New Street to Euston, 6 December 1964. An ex-LNER parcels van is behind the locomotive. *Michael Mensing*

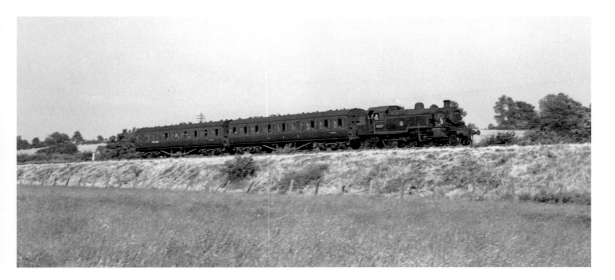

Seen here on 13 June 1959, between Dunchurch and Birdingbury, is Ivatt Class 2 2-6-2T No. 41227 working the 5.35 p.m. Rugby to Leamington Spa (Milverton). *Michael Mensing*

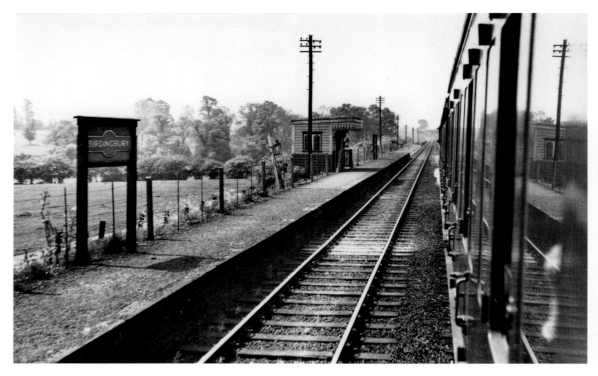

Birdingbury station, view Down, 16 May 1959. Notice the low platform. *E. Wilmshurst*

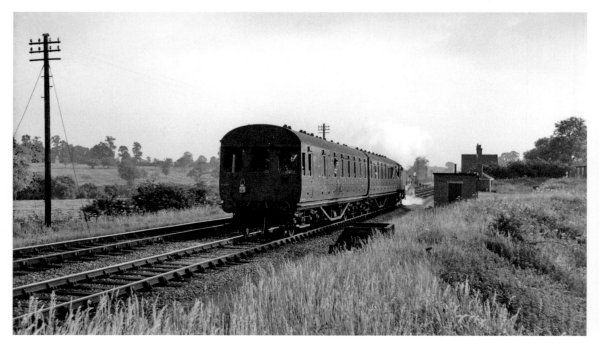

The 7.35 p.m. Leamington Spa (Milverton) to Rugby leaves Birdingbury on 13 June 1959, propelled by Ivatt Class 2 2-6-2T No. 41285. *Michael Mensing*

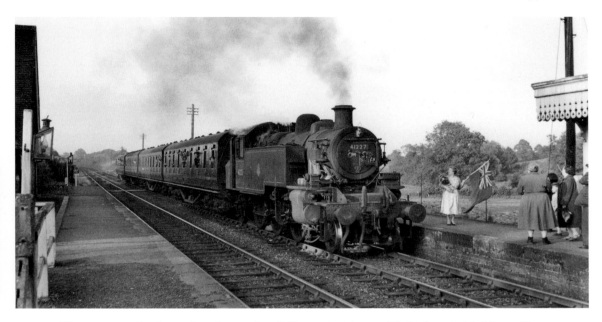

The 7.54 p.m. Rugby to Leamington Spa (Milverton) arrives at Birdingbury behind Ivatt Class 2 2-6-2T No. 41227, the last train on the last day of passenger operation, 13 June 1959. In chalk on the smokebox door is written: 'Oh Sir Brian,' referring to Sir Brian Robertson, the then chairman of BR. The apparatus for push-pull working can be seen on the left of the smokebox. No. 41227 (2C Warwick) was withdrawn from Nine Elms in September 1964. *Michael Mensing*

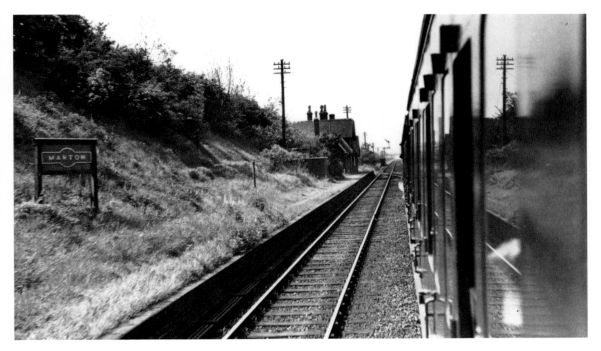

Marton station, view Down, 16 May 1959. Most of the platform is overgrown and only a short section used. *E. Wilmshurst*

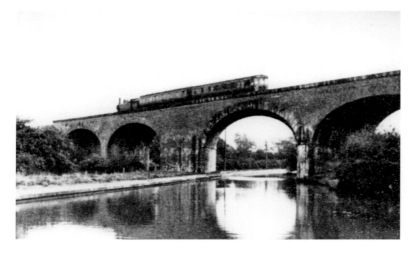

An ex-LNWR 2-4-2T takes a Rugby to Leamington Spa (Milverton) train, an ex-LNWR pull-push set, over Offchurch Viaduct, *c.* 1935. It crosses the Warwick & Napton Canal. *Author's collection*

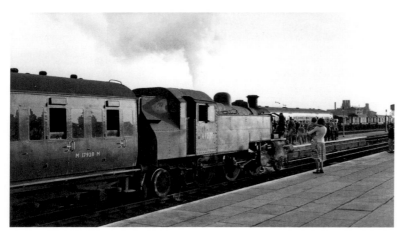

Final branch closing ceremonies are under way around Ivatt Class `2 2-6-2T No. 41227, which is working the 7.54 p.m. Rugby to Leamington Spa (Milverton) at Avenue, the last train on the last day of passenger operation, 13 June 1959. *Michael Mensing*

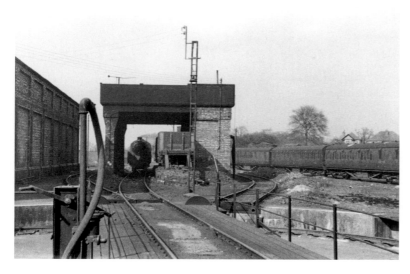

BR Standard Class 5MT 4-6-0 No. 73003 at Milverton shed, 29 April 1956. The turntable in the foreground has a vacuum hose to connect the locomotive's vacuum brake with the vacuum motor. Wagons in the locomotive coal siding are at a higher level to ease transfer. Piles of ash stand between the coal stage and the carriage siding. *Michael Mensing*

Flecknoe to Marton Junction

Following the opening of the branch from Weedon, on the London to Birmingham line, to Daventry on 1 March 1888, Parliament authorised an extension on 4 August 1890 from Daventry to Marton Junction on the Warwick to Rugby line. Although constructed as a single line, bridges, cuttings and embankments were of sufficient width to allow doubling. It opened on 1 August 1895 with no special celebrations, but about eighty passengers arrived at Daventry on the first train. The single line electric train staff installed right from the opening was the first used by the LNWR, which had clung to the train staff and ticket system for some years after most of the other companies had changed to the electrical apparatus.

West of Braunston the branch crossed the River Leam and passed from Northamptonshire into Warwickshire. It then went under the GCR making no connection. In order to avoid heavy cuttings and embankments the branch had quite a few gradients of 1 in 80. It crossed the Oxford Canal before reaching Flecknoe station, which had a single platform on the Up side. Both the low station building and the platform were constructed of timber. Unlike some branches its platforms were of standard height, rather than low, as it was built late in the nineteenth century. As a First World War economy measure, Flecknoe closed to passengers from 1 August 1917 until 1 March 1919. It shut to passengers permanently on 3 November 1952, but livestock was still loaded and unloaded periodically at the siding. The village of Flecknoe was a mile from the station by way of a gated road.

Napton and Stockton had narrow wooden buildings in similar style to that at Flecknoe. A passing loop, single goods siding and small goods shed were provided. Just beyond was a factory on the Down side served by sidings, while Southam cement works was further on. At Southam station, which had another passing place, the Up platform was devoid of buildings. As at Napton, a road bridge served to link both platforms. Six signal levers were in the open on the passenger platform. As the station was 1½ miles from the village, the bus service to Leamington proved much more convenient. From Napton the branch rose at 1 in 84 to Marton Junction, where it joined the double tracked branch from Rugby to Leamington.

A steam railcar was used from 25 January until 19 March 1906 when it was withdrawn, probably due to a chronic shortage of steam on the gradients. Motor train working was introduced on 1 May 1910 using a two-coach compo set. In 1957, with the exception of the first train each way, all were of the push-pull variety and were worked by a Webb 2-4-2T shedded at Warwick and running chimney-first to Weedon. The 2-4-2Ts were replaced by Ivatt Class 2 2-6-2Ts, also motor fitted. Passenger trains were never dieselised. Freight traffic was usually in the hands of LNWR 0-8-0s or LMS Class 8F 2-8-0s, the principal traffic being chalk to Southam cement works, three trains being provided Mondays to Fridays.

The branch closed to passenger traffic on 15 September 1958; Flecknoe and Napton & Stockton's goods service was withdrawn on 2 December 1963 and that at Southam & Long Itchington on 5 July 1965, though trains still ran to the latter, proceeding from Rugby to Marton Junction where a reversal was necessary. In March 1985, the last cement train ran, as BR had lost the contract. An inspection train ran over the line on 17 July 1985, the branch closed on 1 August 1985 and the track was lifted in 1987.

At opening, the branch passenger service offered four trains each way, and in 1901–02 the 5.35 p.m. Euston to Liverpool slipped a coach at Weedon for Leamington. This was worked forward by the 7.38 p.m. mixed train. By 1910 a short working train had been added from Leamington to Napton and the return. By July 1922 the service had increased to eleven each way on weekdays only, including a through coach from Euston to Warwick. In July 1938, ten Down and eleven Up trains were run on weekdays, and seven on Sundays. By 1957 the service had declined to only two trains each way, plus morning and evening trips from Leamington to Napton, primarily for schoolchildren, while there was a 1.50 p.m. Southam to Leamington on Saturdays.

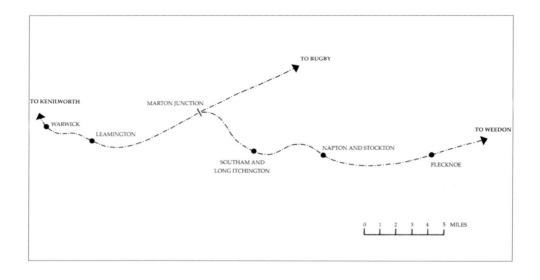

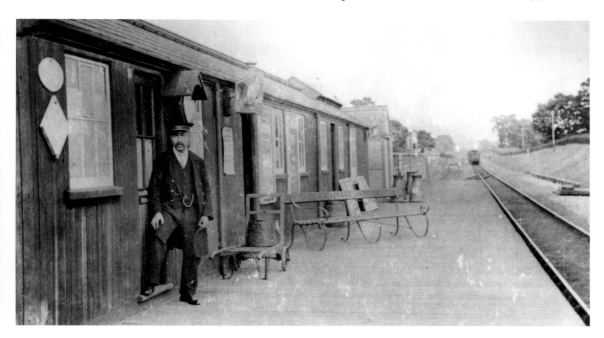

A locomotive approaches Flecknoe tender (or bunker) first in the Down direction, *c.* 1910. Notice the timber building and platform, the large lamps on the eaves, and the clock sheltered by a hood and the four milk churns. The signs to the left of the nearest window indicate the state of repair of the signalling apparatus. *Author's collection*

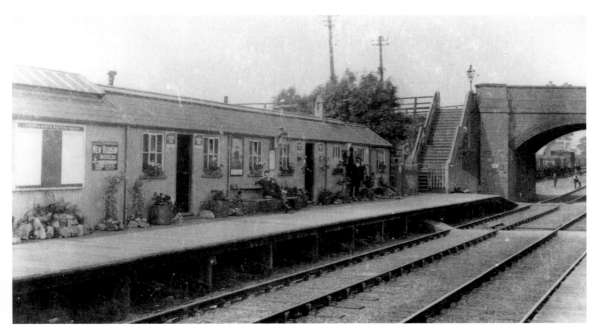

Napton & Stockton station. Notice the outside hooded clock to the left of the stationmaster, the passing loop and the wagons in the goods siding. The station is similar in design to that at Flecknoe. *Author's collection*

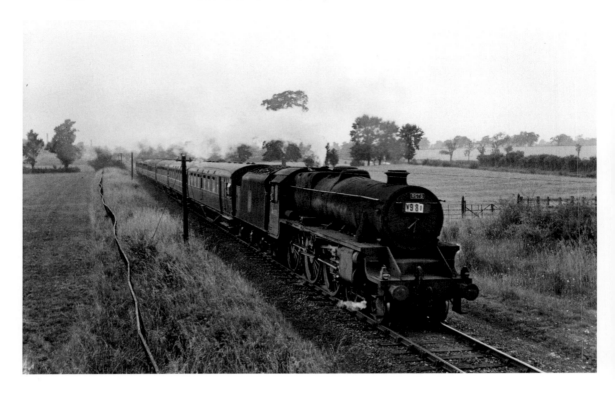

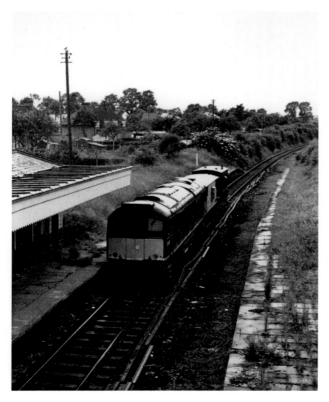

Above: Stanier Class 5 4-6-0 No. 44833, 9 August 1959, on the Railway Correspondence & Travel Society's 'Grafton Railtour', east of Napton & Stockton station after stopping trains had been withdrawn. The coaches are Eastern Region stock. On the left, metal railings form an unusual boundary.
Michael Mensing

Left: BR/Sulzer type 2 diesel-electric Bo-Bo D5137, propelling two brake vans, passes the closed Southam & Long Itchington, 21 June 1966, after working from Rugby to the Southam cement works. *Michael Mensing*

Studley and Astwood Bank
to Salford Priors

The Evesham and Redditch Railway, authorised by Act of 13 July 1863, was an extension of the line from Ashchurch to Evesham, opened in 1864. It provided an alternative route between Gloucester and Birmingham, avoiding the two miles of 1 in 37½ up the Lickey Incline. The Evesham and Redditch Railway was leased on incorporation to the MR. Evesham to Alcester opened to goods on 16 June 1866 and to passengers on 17 September 1866, Alcester to Redditch being opened on 4 May 1868. The branch was especially valuable during the Second World War, when the SMJR was improved so that it could be used as a West Midlands bypass, a south-facing junction being put in at Broom so that trains could avoid reversal. The MR absorbed the company in 1882.

The branch carried vegetables all the year round from the Vale of Evesham to London. Early crops such as cabbages, Brussels sprouts and young onions were transported in March, followed by asparagus until June, which was strawberry time. About 30 tons of this crop was carried daily in June and July in around 1904. In August and September, the principal traffic was plums, 1,000 tons being carried weekly. Autumn and winter saw the carriage of damsons, tomatoes, marrows, cucumbers, apples and pears.

By 1911 the Operating Department realised that the route provided a useful alternative to that via the Lickey Incline and it sent through freights from Washwood Heath to Gloucester, Bath and Bristol via the line. The route saw heavy traffic, particularly freight, during the Second World War. With the development of competing road transport, the branch closed to passengers on 1 October 1962 and to goods on 6 July 1964.

It was built as a single line, only some stations having crossing loops to enable trains to pass. Studley & Astwood Bank, although single track, had quite a substantial brick building, goods shed and four sidings. It dealt with coal traffic for merchants, brick works and needle works, while there was also timber for John Wright's yard. The line fell for 7 miles on a ruling gradient of 1 in 107 to Broom Junction.

Coughton had a single platform and small single-storey building of brick. The single goods loop was worked by two ground frames, but the station was not a block post. It closed to passengers and goods on 30 June 1952.

North of Alcester the branch doubled before the GWR line to Bearley branched off. At Alcester, which had a single platform until the opening of the GWR branch from Bearley, a driver of an Up train was required to give two whistles for Redditch, or three for the GWR branch. The station's architecture was identical with the other Evesham and Redditch stations at Studley, Salford Priors and Harvington. Until 24 April 1932 there was a signal box at each end of the quarter-mile-long loop, but on that date an economy was effected by replacing them with one central box. Cattle were unloaded for the Alcester Co-operative Society's slaughterhouse.

The layout at Wixford was similar to that at Coughton. A temporary station was provided at first, opening on 17 September 1866, slightly later than the others. It was replaced in due course by a timber building, one of the smallest in Warwickshire. The station was not a block post and latterly was mostly used by fishermen, closing to passengers and goods on 2 January 1950.

Approaching Broom Junction a train for Evesham gave one whistle, or three whistles if proceeding to the SMJR. Broom Junction had an island platform with a small brick and timber building. An exchange station with the SMJR, it opened on 2 June 1879 to passengers who were simply transferring from one company to another, and did not appear in the public timetables until 1 November 1880. Block working began over the eighth of a mile between North and South signal boxes on 9 October 1892; these were replaced by one new box on 6 May 1934. Broom Junction opened to goods in February 1882 and was provided with four sidings – two on the Up side and two on the Down. A locomotive turntable was sited on the Up side. In 1896, Broom Junction became a joint station. It closed to all traffic on 1 October 1962. South of the station the SMJR branch curved east, and half a mile beyond a new double track curve (making a third side to the triangle) opened on 28 September 1942. This curve closed on 13 June 1960 and was lifted two years later.

Salford Priors had a single platform and, in addition to the sidings serving the goods yard and shed, a private siding ran into the works of Bomford and Evershed, agricultural engineers. Raw materials were taken inwards by rail, and finished goods outwards. At one time the firm also built steam-rollers. The station closed to goods traffic on 1 October 1962.

In the late nineteenth century, passenger trains would have been worked by Kirtley 2-4-0s and goods trains by his 0-6-0s. By 1900 the line would have seen Johnson 0-4-4Ts and his M class 0-6-0s. His 2-4-0s began to appear on passenger trains just prior to the First World War. In the early 1930s, Deeley 0-6-4Ts and Class 3 0-6-0s appeared, following the strengthening of underbridges. Later that decade Stanier and Fowler 2-6-2Ts and the latter's 2-6-4Ts could be seen with Class 4F 0-6-0s on freight. In the mid-1940s, Compound 4-4-0s, Belpaire Class 3 4-4-0s and Hughes 'Crab' 2-6-0s appeared on the line. The 1950s saw Ivatt Class 4 2-6-0s on both passenger and freight working, and Class 5 4-6-0s, Class 8F 2-8-0s and Class 9 2-10-0s on freights.

The initial service between Evesham and Alcester offered four trains each way on weekdays and two on Sundays. The opening of the line through to Redditch and Birmingham in 1868 allowed through services. In August 1887, the passenger service offered four trains each way daily and none on Sundays; in 1910 there were seven each way and still none on Sundays; while by July 1922 there were six daily and two on Sundays. In August 1938, seven trains ran daily and five on Sundays – the latter a surprisingly high figure.

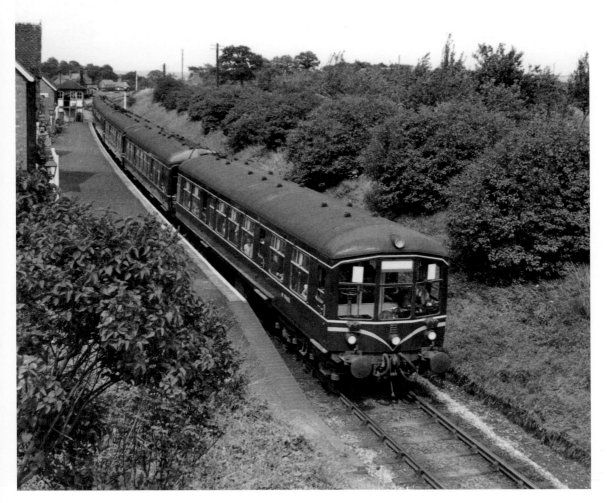

Passing Studley & Astwood Bank is a train consisting of three two-car Derby lightweight DMUs, driving trailer composite M79655 leading, working an excursion from Birmingham New Street to Evesham, 12 August 1956. This design of DMU permitted passengers in the front seats to enjoy a splendid panoramic view. The driver is in steam day's uniform. The handbrake pillar is set unusually high in this early DMU. *Michael Mensing*

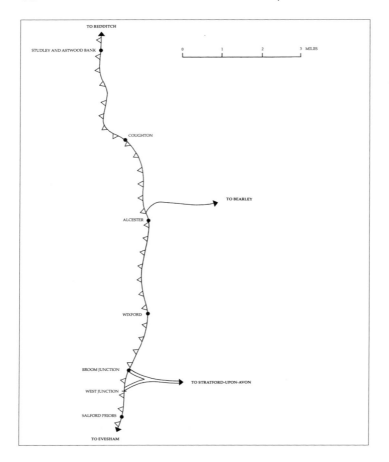

TO REDDITCH

STUDLEY AND ASTWOOD BANK

COUGHTON

TO BEARLEY

ALCESTER

WIXFORD

BROOM JUNCTION

TO STRATFORD-UPON-AVON

WEST JUNCTION

SALFORD PRIORS

TO EVESHAM

0 1 2 3 MILES

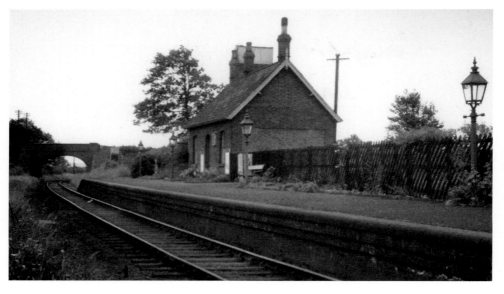

The empty-looking platform at Coughton, view Down, *c.* 1930. Notice behind the chimney, the unsightly water tank with a corrugated iron lid. *Lens of Sutton*

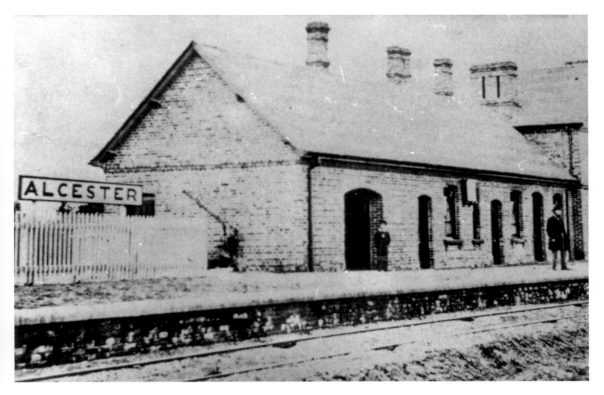

A *c.* 1875 view of Alcester station before the track was doubled. *Author's collection*

I. 20a. 3650.
"SHAKESPEARE ROUTE."
S. M. J. Rly.
ALCESTER
(Mid.)

A Stratford & Midland Junction Railway luggage label to Alcester. *Author's collection*

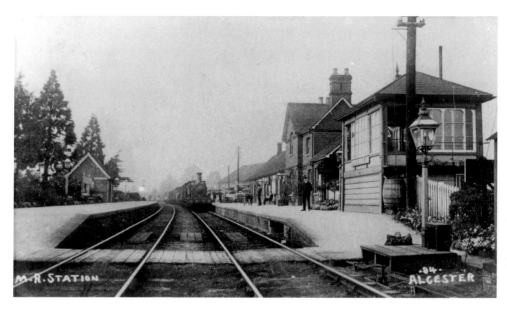

An MR locomotive, probably a straight double-framed Kirtley 0-6-0, heads Down goods at Alcester, *c.* 1906. The goods shed can be seen at the far end of the passenger station. A cattle wagon stands to the right of the locomotive. This signal box, dating from December 1905, replaced an earlier one; notice the water butt beside it. The bars of the lamp standard to support a ladder are superfluous here as a platform is provided for the lamp-lighter. The lamp's reflector is well-polished. Perhaps it is the photographer's bag that stands at the foot of the lamp. The card, postmarked 24.12.09, has 'Best Wishes for Christmas' written on the back. *Author's collection*

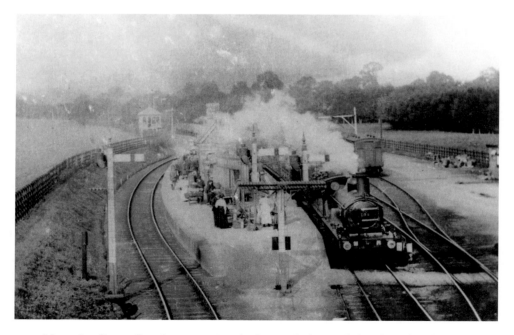

2-4-0 No. 108 at Broom Junction, *c.* 1908, waits for a train from Ashchurch to clear the single line, as do the passengers. *Author's collection*

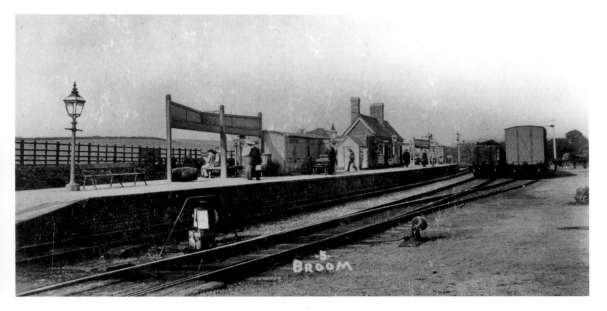

Broom Junction, view Up: the rear of the running-in board is prominent. Notice the weighted point lever and the grounded van on the platform is use as a shed. At the far end of the platform, Broom North signal box can be seen. *Author's collection*

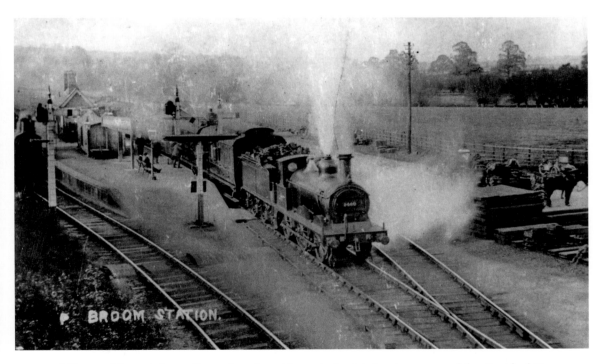

MR 0-6-0 No. 3460 leaves Broom Junction with a train for Ashchurch, *c.* 1910, while a Stratford & Midland Junction Railway train stands on the far left. In 1933, No. 3460 was an early withdrawal of its class. Note an early car beyond the horse. Behind the cloud of steam is a pile of sleepers. *Author's collection*

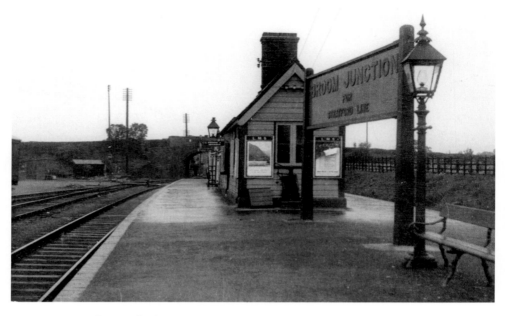

'Broom Junction for Stratford Line,' view Down, in pre-nationalisation days. An oil lamp stands on the right, a finger-board indicates a train to Evesham & Ashchurch, and beneath the window is an Avery weighing machine. *Lens of Sutton*

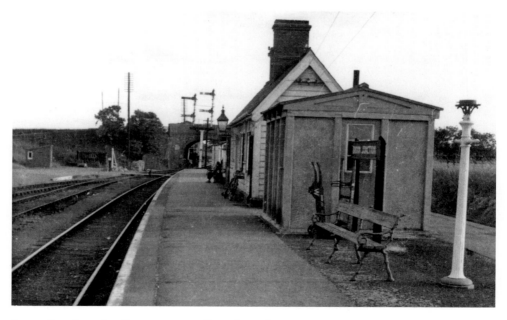

Broom Junction, view Down, *c.* 1960. Since the earlier view, a concrete hut has replaced the large name board, while tall upper quadrant signals have replaced the MR lower quadrants. The upper portion of the nearest lamp is missing. *Lens of Sutton*

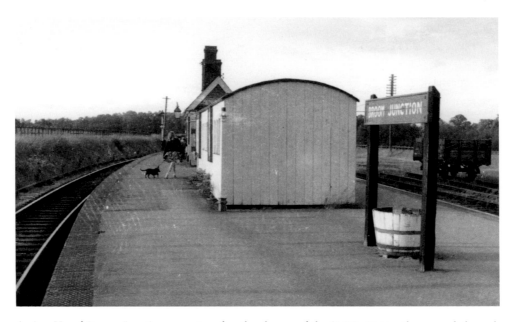

A view Up of Broom Junction, *c.* 1960, after the closure of the SMJR. Notice the grounded coach body acting as auxiliary accommodation. The station name board is a poor substitute for the Midland pattern. *Lens of Sutton*

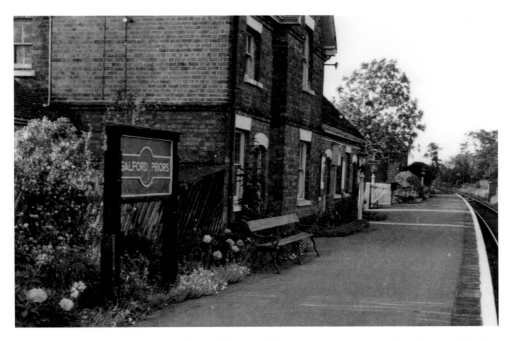

Salford Priors, view Up, *c.* 1960, lit by oil lamps. The platform edge is neatly whitened. The hut containing the ground frame for working the siding can be seen on the right opposite the far end of the platform. *Lens of Sutton*

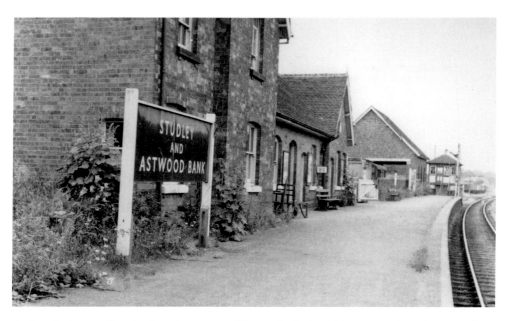

Studley & Astwood Bank, view Up, *c.* 1960. The goods shed, which seems to have been rebuilt to some extent, has an unusually high pitched roof and on the photographer's side of it is an SR utility van. Milepost 60 stands beside the platform seat. The station staff seem too busy to attend to the garden. A store, constructed from concrete, stands between the passenger station and goods shed. *Lens of Sutton*

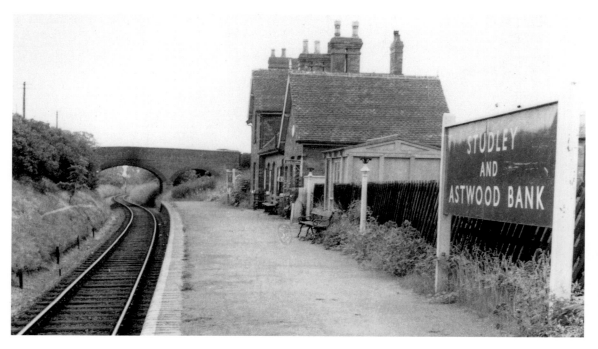

Studley & Astwood Bank, view Down, *c.* 1960. The station is well-off for fireplaces. The platform has a somewhat unkempt appearance. *Lens of Sutton*

M.R. SECTION No. 85. BIRMINGHAM CONTROL.

FROM BARNT GREEN JUNCTION TO EVESHAM LINE JUNCTION, VIA

THROUGH DISTANCE			DEPOT WORKING.	No. of Train.	Page in Working Time Table.	TIME IN SECTION.							
M.	C.					STANDARD.	Fri.	Sat.	Sun.	Mon.	Tues.	Wed.	Thur.
		Barnt Green Junction.											
0	2	Barnt Green											
1	69	Alvechurch											
4	43	Redditch Gas Works Sidings											
6	7	Redditch Station											
8	21	Studley											
10	36	Coughton											
12	42	Alcester											
14	40	Wixford											
15	17	Broom Junction Station											
16	48	Salford Priors											
18	49	Harvington											
22	6	Evesham											
23	47	Bengeworth											
25	26	Hinton											
27	46	Ashton-under-Hill											
29	46	Rockford											
34	64	Ashchurch (Evesham Junc.)											
35	75	Ashchurch Station											
35	0	Evesham Line Junction											

DISTANCE FROM PREVIOUS POST. — Sat. | Sun. | Mon. | Tues. | Wed. | Thurs.

Midland Railway Route Card, Barnt Green to Evesham.

Broom Junction to Stratford-upon-Avon and Fenny Compton

On 23 June 1864 the East and West Junction Railway Act authorised a link between the Northampton and Banbury Junction Railway and the GWR at Stratford-upon-Avon. One of the line's aims was to transport Northamptonshire iron ore to South Wales blast furnaces, where local supplies had been exhausted. In the event, this hope of using Northamptonshire ore was never fully realised as Spanish ore proved cheaper. The contractor building the EWJR was Thomas Russell Crampton (1816–88), who had assisted Daniel Gooch in planning the GWR's Fire Fly class 2-2-2 locomotives. Crampton later designed on his own a patent locomotive with a large boiler and low centre of gravity, many of which were exported to Belgium, France and Germany. Crampton was interested in the Channel Tunnel project and invented a boring machine to pulverise chalk, mix it with water and sluice the mixture out. He also laid across the Straits of Dover the world's first international submarine cable. The construction of the EWJR had its effect on the economy of Warwickshire as some farm hands became navvies in order to receive higher pay, and women and children worked in brickyards to supply the contractor with building material.

The EWJR opened from Fenny Compton to Kineton on 1 June 1871 and through to the GWR at Stratford-upon-Avon on 1 July 1873. In June 1875, it used its own station in the town. Earlier that year the company had fallen into financial difficulties and went into receivership. Passenger traffic was suspended from 31 July 1877 until 22 March 1885; during this period only goods trains were run. The EWJR supported the Evesham, Redditch and Stratford-upon-Avon Junction Railway, which on 5 August 1873 received an Act to build a line from Stratford-upon-Avon to Broom Junction, but the EWJR's running powers to Evesham and Redditch were never exercised. The Evesham, Redditch and Stratford-upon-Avon Junction Railway opened on 2 June 1879 and was worked by the EWJR which, unlike on its own line, provided both passenger and goods services. Binton was the only intermediate station between Broom and Stratford-upon-Avon, Bidford not being opened until 1881 when it first appeared in the May edition of *Bradshaw*. LNWR goods trains commenced running from Blisworth to Broom Junction on 15 March 1886.

The impecunious EWJR sold hay from its cuttings and embankments to local farms, and an apocryphal tale said that a good hay harvest meant new uniforms!

The EWJR did its best to secure traffic, huntsmen being encouraged by the 1900 timetable cover, which read: 'Hunting Arrangements. During the season First-Class Return Day Tickets are issued to Hunting Passengers at Single Fare and a Half when accompanied by their horses, which are then conveyed at a Rate and a Half for the Double Journey at Owner's Risk. Return tickets issued to their grooms at the same time. Rate according to class of carriage used.' A hound van and horse boxes were kept at Kineton for the Warwickshire Hunt.

In 1908, the Stratford-upon-Avon and Midland Junction Railway was formed from amalgamation of the East and West Junction Railway, the Evesham, Redditch and Stratford-upon-Avon Junction Railway and the Stratford-upon-Avon, Towcester and Midland Junction Railway.

In 1910, the *Railway Magazine* reported that the grass growing in the SMJR ballast had been uprooted and that although the railway had the makings of a valuable through line linking four great railways (the GCR, GWR, LNWR and MR), hardly anyone used its capabilities and there was little industry adjacent to the line, so it had to exist on purely local traffic. The MR routed its Bristol and Gloucester to London traffic over the SMJR until 1912, but after this date used its own metals throughout via Wigston Junction, just south of Leicester, thus causing the SMJR to lose £1,100 per annum from banana traffic revenue alone. In BR days, Bristol to Bristol St Philip's goods traffic travelled via the SMJR and reached London earlier than if it had travelled via Swindon.

The SMJR was certainly in the forefront of technology. The East and West Junction Railway had introduced electric lighting in its coaches in around 1900, and by 1910 all were electrically lit – more than could be said for the larger railway companies. Then in July 1912, a radio message was transmitted from a train between Ettington and Stratford: 'Representatives of railway companies, universities and scientific bodies are today inspecting the Von Kramer wireless inductive railophone system for signalling to and from trains to stations. With this system it is possible to stop trains in motion by pressing a button in a signal box. This telegram was dispatched wirelessly from a moving train by the inventor.'

Innovation continued in post-Grouping years when the LMS introduced the Karrier Road-railer. Designed by J. Shearer of the LMS, it was a twenty-two-seater passenger bus capable of running on either rail or road. Its body, built by Messrs Craven, was like an ordinary contemporary road bus except that it had a passenger door on both sides. The body had two compartments and a centre vestibule. The front compartment seated fourteen facing forward, while the rear, a smoking compartment, seated twelve longitudinally. Hot air heating was introduced by the Thermo-Economic system. Like the coaches of the period, provision was made for carrying luggage on the roof. It was in a livery of crimson lake with a white roof. Karrier Motors Ltd built the chassis. Powered by a six-cylinder 120-hp petrol engine, it had a top gear ratio of 7:1 for road use and 4.2:1 for rail, giving maximum speeds of 60 mph and 75 mph respectively,

The Stratford-upon-Avon & Midland Junction Railway's entry in the *Railway Year Book, 1922.*

An extract from Karrier Motors Limited's publicity material for the *Road-Railer.*

though in reality the Ministry of Transport restricted its speed on public roads to 30 mph as it did with all heavy vehicles. Petrol consumption on the road was 8 mpg and 16 mpg on rail; rail consumption was notably less due to the reduced rolling resistance and the fact that overdrive could be engaged. Sanding gear was fitted for use when conditions made the rails slippery.

Flanged wheels were fitted to the vehicle's axles and on the outside of these were pneumatic-tyred road wheels, each of which was mounted on eccentrics fitted to an axle extension through the rail wheel. When on the road, the road wheels were locked concentrically to the rail wheels, which, being of smaller diameter, were clear of the ground. On rails, the road wheels were eccentric to the rail wheels. The change could be carried out in 2½ minutes. For quiet running the rail wheels were Lang pattern laminated wheels with detachable steel tyres. A steel back plate shielded the wood from brake drum heat. The Lang wheel possessed resilience and exceptional strength.

For road to rail transfer the Road-railer was driven to a place where the rail surface was flush with the road. At Stratford a special siding catered for the exchange rail to road or vice versa and passengers were not required to leave their seats. Then, with the rail wheels directly above the lines, it was driven forward a few yards until it reached a spot where the road surface tapered off. This caused the rail wheels to gradually come into contact with the rails and took the vehicle's weight off the road wheels. The latter, mounted on an eccentric, were raised above rail level by the driver who turned them on their eccentrics and locked them to the chassis by means of a pin. The road wheels did not rotate when the coach was on the rails. The rear wheels were driven by a shaft in the same way as an orthodox road vehicle and were provided with sanding gear. The average time for changeover road to rail or vice versa was about four minutes.

The LMS had opened the luxury Welcombe Hotel (designed as a mansion by Henry Clutton in 1869) at Stratford-upon-Avon on 1 July 1931. From 23 April, Shakespeare's birthday, until 2 July 1932, the Road-railer ran three miles from the hotel, where it was garaged overnight, to the station and then onwards by rail to Blisworth, where passengers could change into a London train. It then returned to Stratford with passengers from London. Although a mechanical success, at 7 tons 2 cwt it was too heavy for its engine and was withdrawn after the front axle broke at Byfield. The Road-railer was replaced by an ex-MR class 1P 0-4-4T and an ex-MR brake composite. The Welcombe Hotel is now a Grade II listed building.

The Broom Junction to Stratford-upon-Avon passenger service was withdrawn on 16 June 1947, followed by the passenger service east of Stratford on 7 April 1952. On 7 March 1960 the connection at Fenny Compton was remodelled to provide a facing connection in order to facilitate the running of 800-ton iron ore trains from Banbury to South Wales, and thus form an alternative route to the Banbury and Cheltenham Direct Railway, part of which had by then been closed. A southwards facing junction was put in at Stratford-upon-Avon leading to the south of the Racecourse station. This curve opened on 24 April 1960 and was first

An advertisement for the LMS Welcombe Hotel.

Above: The Stratford-upon-Avon & Midland Junction Railway Company's seal.

Left: The Stratford-upon-Avon & Midland Junction Railway's advertisement in the *Railway Year Book,* 1921.

worked on 12 June that year. This rendered the section from Stratford to Broom Junction redundant and so this was closed on 13 June 1960. In the late 1950s, all loops of the SMJR had been lengthened to accommodate sixty-wagon trains and the edges of disused platforms trimmed to permit ex-GWR engines to work over the line; up to four trains ran daily. Points of the lengthened loops distant from a signal box were motor-worked. The ore traffic soon declined and in 1965 the SMJR was closed from the Ministry of Defence Central Ammunition Depot sidings at Burton Dassett to Stratford-upon-Avon, the line from Fenny Compton to Burton Dassett being sold to the Ministry of Defence on 18 July 1971.

Soon after passing Broom East Junction signal box at the eastern apex of the triangular junction, the single line crossed the 40-yard-long, three-span-girder River Arrow Viaduct. Bidford, opened around April 1881, became Bidford-on-Avon on 1 July 1909. It had a short single platform and two sidings beyond. The station's booking office economically utilised the arch of an overbridge, a stovepipe rising to just above the bridge parapet, tempting boys to block it with rags. The station's waiting room was a grounded coach body and parcels were kept in a corrugated iron shed. Bidford was not a block post and up to ten wagons could be propelled to Broom Junction. As a First World War economy Bidford closed from 19 February 1917 until 1 January 1919, and closed permanently to goods traffic on 7 March 1960.

Binton had one platform, a goods shed and siding, the latter used by a brick and tile works that sent away several truck loads daily. Binton and Bidford both dispatched many plums during the season. Binton was not a block post and up to ten wagons could be propelled to Stratford. Its goods yard closed on the same day as Bidford's.

The SMJR crossed the GWR past extensive sidings and a trailing connection from the GWR. SMJR headquarters were at Stratford-upon-Avon, its offices being by the Up platform, while the loco, carriage and wagon repair shops were near the Down platform. The telegraphic address of the SMJR at Stratford-upon-Avon was 'Regularity'. The station, tucked away in back streets, had a refreshment room and, like all those on the SMJR to the east, had two platforms. Those at Stratford-upon-Avon were unusually far apart; perhaps the original temporary station was an island. Using a stationary boiler and dynamo the station generated its own electricity, a battery being used from 10 p.m. to 6 a.m. when the generator was out of use.

The engine shed held fourteen locomotives. Built of timber, it opened in 1876, was extended in 1908 and reconstructed in 1935. In 1908, a large turntable was installed so that GCR Atlantics could turn after working excursions to Stratford. Allocation of engines to Stratford-upon-Avon ceased in February 1953, though engines continued to be serviced until the shed's closure on 22 July 1957. The SMJR had its own Merryweather steam fire engine based at Stratford. It was purchased in 1909 for £115. In the event of a fire anywhere on the company's property, in addition to calling out the local brigade, Stratford shed had to be

notified so that the SMJR's fire engine and fire fighting team could leave by special train. A shovel of fire was taken from a locomotive to raise steam in the fire engine, sufficient pressure to work the pump being raised in ten minutes.

Even more than most railways, the SMJR had the welfare of its staff in mind: free travel to a more distant school was offered to employees' children if the local school was unsuitable. Fogmen not only had warm overcoats supplied, but were also given refreshments – hot tea, cocoa, coffee and bread, butter and cheese.

The line beside Stratford goods shed led to two private sidings: Lucy and Nephew's cornmill on the banks of the Avon, and a government grain silo. In 1964, twelve years after the withdrawal of the passenger service, a short length of the Up platform was resurfaced for Her Majesty The Queen Mother to board the Royal Train when it spent a night in Clifford Sidings, before returning to Stratford and proceeding to Honeybourne.

East of Stratford, the Avon was crossed by a six-arch viaduct having a total length of 69 yards. It was completed only three months after the foundation stone was laid on 28 September 1864. Three-quarters of a mile beyond the bridge was Clifford Sidings, which during the Second World War handled traffic for Atherstone airfield. As a runway was adjacent to the railway, the RAF installed colour light signals that could be operated from the control tower in order to stop a train in an emergency. These lights were continuously lit and repeated in Clifford Sidings signal box. The RAF tested the signals daily at noon, and they proved useful when a Wellington with full load of bombs and fuel crashed on the line. A platform was built near the airfield for use by RAF personnel, but was burnt down soon after the end of the Second World War. The track was doubled between Stratford and Clifford Sidings on 27 September 1942.

Just beyond Clifford Sidings was the iron girder bridge carrying the Stratford and Moreton Tramway over the line. Here the SMJR was in Goldicott Cutting, on a rising gradient of 1 in 80 for Up trains. It was 60-ft deep and 600 yards in length, and the only formation not of double track width. It was the deepest cutting in Warwickshire and troubled by frequent falls of limestone. An occupation bridge over the cutting collapsed on 24 September 1914. The steelwork of the replacement bridge was laid out unwisely on the old bridge, causing it to collapse.

A mile short of Ettington was the Ettington Lime Works Siding, which closed in about September 1918. Ettington itself had a goods shed and two sidings, while Kineton had a goods shed and six sidings. Kineton signal box had an extension at both ends to accommodate the electric train staffs and when the station platforms were removed a small stage was provided for the signalman to stand on when exchanging tokens with footplate crews.

Burton Dassett saw quite a few changes. Burton Hill Sidings came into use when the ropeway to the iron ore mines opened in 1873, but the ropeway closed the same year, reopening from 1895 to 1909. Burton Dassett workmen's platform opened on 1 December 1909 on the site of Warwick Road station, which closed in June 1873. Further west were the exchange sidings for the Edge Hill Light

Railway, taken over for War Department use in 1939. Ex-GWR Dean Goods 0-6-0s were used and in addition to shunting, worked a thrice weekly 'off-duty' train to Fenny Compton where a connection was made with GWR trains to Leamington Spa. From 5 October to 9 November 1945, ex-LMS 0-6-0 diesel shunter No. 7062, as WD 70215, shunted the depot. Army sentries prevented locomotive crews from getting off the engine, but were willing to fill a can with cocoa. Ammunition trains were often double-headed from Avonmouth to Burton Dassett – not so much as for power, but to prevent the emission of sparks when working hard. Although some ammuniton vans were steel-lined, many were just plain wood.

In 1947, as an experiment, radio, instead of telephone, was used to control train movements, but had to be abandoned as it interfered with radio signals from the local RAF station.

In 1965, a 600-hp 0-8-0 diesel-hydraulic locomotive was built by Andrew Barclay and classified D3. Due to end overhang on tight curves causing gauge fouling, the class was generally confined to the Bicester Military Railway, though an exception was made for one to work over the 3½ miles of ex-SMJR between Burton Dassett and Fenny Compton, which included a gradient of 1 in 100.

Between 1955 and 1958 Kineton received no less than twelve Wickham Type 40 railcars powered by 30-hp Ford V8 engines. Such a large number were required due to the high mileage of track linking the numerous storage depots. For moving small consignments, railcars and trailers were more economical than locomotive-hauled trains. In 1968, the depot received three fire tenders, built by Messrs Clayton using an adapted railcar design. Still used by the Ministry of Defence, the depot today is also used for the safe storage of off-lease main line stock.

Almost three-quarters of a mile further on was North End which, like Warwick Road, was not reopened when passenger services resumed in 1895. The SMJR station at Fenny Compton was parallel with that of the GWR, but until 1960 no through running was possible without reversal. A level crossing was available for use when the underline bridge was flooded. A new signal box opened by the LMS on 29 May 1931 also controlled the GWR line, separate frames being provided for each railway.

A variety of locomotives worked on the SMJR, some new and some second-hand. One unusual machine was a Fairlie 0-6-6-0T, the first engine in England with Walschaert's valve gear. Edge Hill Light Railway engines were occasionally used on the SMJR. As there is no mention in the SMJR accounts of maintenance of the Edge Hill engines carried out at Stratford, it is believed that they were used on Stratford to Broom Junction trains in return for work carried out on them. In LMS days, traffic was worked mainly by ex-MR 0-6-0s, but also Lancashire and Yorkshire 0-6-0s and MR 0-4-4Ts. In the 1950s, iron ore trains were hauled by 2-8-0s of either the LMS Class 8F or War Department variety. From 1960 BR Standard Class 9F 2-10-0s were used. Ex-LSWR Jubilee Class 0-4-2 No. 643 was transferred to Burton Dassett in August 1943 until April 1944 for working army leave and recreational trains from Kineton Depot to Fenny Compton and Stratford.

In the LMS era, passenger trains usually consisted of an ex-MR Class 3F 0-6-0 and one coach. The East and West Junction Railway's locomotive livery was black with green lining edged with yellow, while the passenger coaches, all six-wheelers, had cream upper and lake lower panels. A curiosity was an absence of passenger communication equipment, this flouting the requirements of the 1868 Act.

The 1871 service showed six trains each way from Fenny Compton to Kineton and five when the line opened through to Stratford, six being provided in 1874, two in 1876 and the service suspended entirely in 1877. For the opening of Broom Junction to Stratford on 2 June 1879, five trains were run each way and tank engines were prohibited from running bunker first between Stratford and Broom. From 1890 the LNWR ran 'Shakespeare Specials' to Stratford every Saturday in spring and summer. By 1902 through coaches left Stratford every weekday for Euston at 3 p.m. From 16 June 1902 through coaches were attached to two trains from Marylebone and on the East and West Junction Railway only stopped at Kineton. The journey from the capital took only two hours ten minutes compared with three hours by LNWR and two hours thirty-five minutes by GWR. As the EWJR used the Westinghouse brake and the GCR and LNWR used vacuum, the coaches from the GCR had to be worked alone by an EWJR engine (some EWJR locomotives were fitted for both brakes), whereas LNWR coaches were dual fitted and could work with EWJR stock. Although EWJR coaches were steam heated, drivers were reluctant to connect it as on a rising gradient they wanted to save the steam for locomotive traction.

In 1909, four trains were run daily from Broom to Stratford and six from Stratford to Fenny Compton, while in 1933 the figures were four and three respectively. The withdrawal of the slip coach at Woodford on 1 February 1936 meant the ending of a through coach from Marylebone to Stratford by the shortest route of 93¼ miles, compared with the 102¾ miles by GWR via Bicester. Stratford-upon-Avon was one of the few towns to which the GCR could claim a shorter route from London than any other company. Even in 1939 one could make the journey in two hours twenty minutes by changing trains at Woodford. In 1950, three trains ran from Stratford to Fenny Compton.

Sec., C. Banks.]				EAST AND WEST JUNCTION.						Traffic Man., J. F. Burke.				
Euston Station,	mrn	mn	aft	aft	aft	aft	Temple Mead Sta.,	mrn	mrn	mrn	aft	aft	aft	
LONDON **186** ..dep	7 15	9 30	1 03	0 6	6 0	BRISTOL 266 dp	8 0	3 20		
NORTHMPTN(Cstl)	8 50	1125	2 25	4 20	7 52	263 BIRMINGHM*	6 40	9 43	1 35	5 15	
Blisworthdep	9 c 0	1140	2 44	4c41	8 5	Broom Junc...dep	8 27	11 7	2 46	6 11	6 32	
Towcester	9 15	1155	2 59	5 1	8 21	Bidford............	8 30	1110	2 49	6 14	6 36	
Blakesley	9 26	12 6	3 9	5 10	8 30	Binton............	8 38	1117	2 56	6 21	6 44	
Morton Pinkney......	9 33	1219	3 16	5 17	8 37	Stratford-on- { ar	8 45	1124	3 4	6 29	6 52	
Byfield	9 41	1228	3 25	5 25	8 45	Avon † **25** {dp	7 10	8 55	1126	3 8	6 32
Fenny Compton 20,23	9 54	1242	3 39	5 39	9 0	Ettington	7 20	9 6	1136	3 18	6 42
Kineton	10 5	1253	3 50	5 50	9 11	Kineton........[23	7 29	9 15	1145	3 27	6 51
Ettington	1012	1 2	3 59	6 0	9 20	Fenny Comptn 20,	7 40	9 26	1156	3 38	7 2
Stratford-on- { a mrn	1022	1 13	4 9	6 10	9 30	Byfield	7 55	9 42	1210	3 52	7 18
Avon † **25** {d	7 50	1024	2 20	3 30	5 40		Morton Pinkney..	8 4	9 51	1218	4 0	7 26	
Binton	7 57	1031	2 27	3 45	5 47		Blakesley	8 12	9 59	1226	4 7	7 33	
Bidford	8 5	1039	2 34	4 0	5 55		Towcester *(below)*..	8e20	10 8	1233	4e15	7 40	
Broom Junc. 263a	8 8	1042	2 37	4 5	5 58		Blisworth 191, 186	8 35	1023	1248	4 35	7 55	
263 BIRMINGHAM a	1212	6 0	6 0	7 45		NORTHAMPTN a	9 14	1043	12 2	4 50	8 15	
BRISTOL 265	1140	2 5	5 25	1135		191 LONDON(Eus.)	1030	1210	2 35	6p45	1015 b		

* New Street Station. † New Street Station. ¼ mile from the Great Western Station.

BYE-LAWS
Rules and Regulations

TO BE OBSERVED BY

THE OFFICERS AND SERVANTS

OF THE

EAST AND WEST JUNCTION
RAILWAY COMPANY.

1st JUNE, 1873.

LONDON:
McCORQUODALE & Co., PRINTERS, "THE ARMOURY," SOUTHWARK.

MDCCCLXXIII.

10 GENERAL REGULATIONS.

from duty, or absent through sickness or any other cause, will be stopped; and the Company reserves to itself the right of deducting from the pay of any servant such sums as he may owe the Company.

10. Every servant must appear on duty clean and neat; and when uniform is provided, it must be kept and used with care, and any damage must be repaired at the wearer's expense; on leaving the service he will be required to deliver up to his superior officer the uniform and every other article supplied by the Company. All servants of the Company to whom uniform is allowed are required to wear it while on duty.

11. UNIFORM will be supplied as follows :—

To Ticket Collectors, Guards, Parcels Delivery Men, Police, and Signalmen, ONE SUIT annually on the 1st of June, and an extra pair of trousers on the 1st December.

To Porters, Gatemen and others wearing corduroy, a sleeve waistcoat, pair of

GENERAL REGULATIONS. 11

trousers, and cap, on the 1st June, and a jacket and pair of trousers on the 1st December every year.

12. Each person will, so long as he remains in the service, be allowed to retain for his use two articles of every description of clothing supplied to him (except top coats), so that he may always have the comfort of a change, and also to enable him to use his oldest clothes for rough jobs and in dirty weather, and appear well dressed on other occasions. Thus, whenever a third article of the same description is issued to any servant he must deliver up the first, when a fourth is issued he must deliver up the second, and so on.

13. TOP COATS, to whomsoever they may be allowed, by the General Manager, will be issued every two years, and the old coat must always be given up in exchange for the new.

14. All clothing supplied by the Company must ultimately be returned to the Storekeeper. No person may sell or transfer it under pain of legal prosecution, and the Company reserves to itself the

East & West Junction Railway's
Rules & Regulations.

136

I, the undersigned, having been appointed

in the service of the East and West Junction Railway Company, hereby declare that the foregoing Instructions and Regulations have all been carefully read over by and fully explained to me, that I clearly understand them and have received a copy of the same, and I hereby bind myself to obey and to abide by these Regulations. As witness my hand, this day of 187

Witness to Signature, }

Opposite: East & West Junction Railway timetable, August 1887.

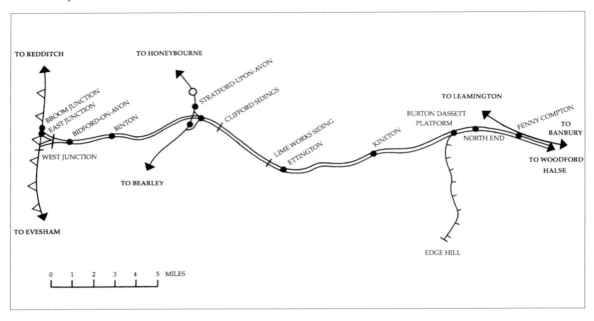

Manning Wardle 0-6-0ST No. 1, built in 1866, which worked the first passenger train on the East & West Junction Railway. The cab was an afterthought – compare with the picture on page 94. *Author's collection*

Opposite above: SMJR 2-4-0T No. 5 built by Beyer Peacock in 1885. It was originally ordered by the Midland & South Western Junction Railway, but this company was impecunious, so it was sold instead to the East & West Junction Railway. It is seen here *c.* 1910. In 1916, No. 5 was sold to the War Department for £1,000 and became WD No. 9 on the Catterick Camp military railway. *Author's collection*

SMJR 0-6-0 No. 18 at Stratford-upon-Avon, *c.* 1910, in spotless condition, with burnished buffers and smokebox door brackets. Built by Beyer Peacock in 1908, on amalgamation it became LMS No. 2311 and was withdrawn in 1927. Notice that the lower headlamp is reversed. A water crane and 'devil' stand on the right. *Colin Roberts' collection*

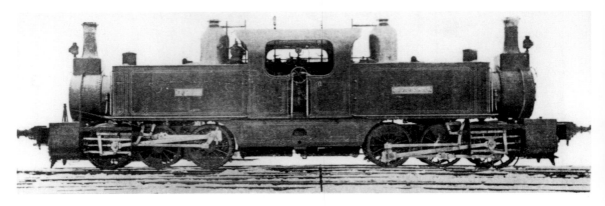

East & West Junction Railway Fairlie patent o-6-6-oT built by the Yorkshire Engine Company, 1873. The driving wheels are close-coupled and the centre wheels appear to be flangeless. It was the first locomotive working in the British Isles to be fitted with Walschaerts valve gear. After the suspension of passenger traffic in 1877, it was disposed of the following year. *Author's collection*

An undated SMJR handbill. *Author's collection*

Right: An extract from the SMJR's *Programme of Week-end, Tourist, Picnic and Pleasure Party Arrangements 1913-14. Author's collection*

Below: SMJR 0-6-0 No. 7, built by the London, Brighton & South Coast Railway in 1884. Their No. 428, it was sold to the SMJR in November 1920. Following the 1923 amalgamation it became LMS No. 2303 and was withdrawn in 1924. Sister engine LBSCR No. 430 in 1914 hauled a troop train from Brighton to Doncaster. *LPC/Colin Roberts Collection*

SATURDAY to MONDAY TICKETS.

ARE ISSUED BETWEEN ANY TWO

S.M.J. STATIONS

—— ALSO TO ——

Stations on the following Companies' Lines:

Barry.	Midland (Excluding London, Tilbury and Southend Section.)
Brecon and Merthyr.	Midland and Great Northern Joint.
Cambrian.	
Cheshire Lines Committee.	Midland and South Western Junction.
Cockermouth, Keswick & Penrith	
Furness.	Manchester, South Junction and Altrincham.
Great Central.	
Great Eastern.	Neath and Brecon.
Great Northern.	North Eastern.
Great Western.	North London.
Hull and Barnsley.	Rhymney.
Knott End.	Severn and Wye.
Lancashire and Yorkshire.	Somerset and Dorset.
London and North Western.	Taff Vale.
London & South Western (With certain exceptions.)	Wirral.
Maryport and Carlisle.	And other Companies.

Also to Ireland.

—— AT A ——

SINGLE FARE and a THIRD.

(Plus Fractional Parts of a Penny) for the Return Journey.

MINIMUM FARE	First Class, 4/0
	Third Class, 2/6

	OUTWARD:—
AVAILABILITY	SATURDAY.
	RETURN:—
	Following MONDAY.

LUGGAGE.—150 lbs. First Class, 100 lbs. Third Class, allowed FREE.

Further Particulars may be obtained at the Stations and at :—
Mr. STANTON'S, Ye Five Gables,
Chapel Street, Stratford-on-Avon.

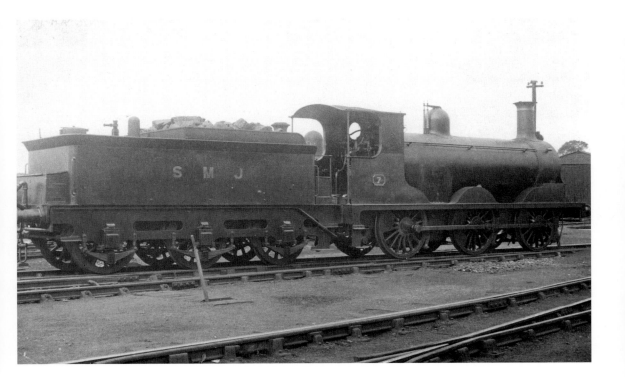

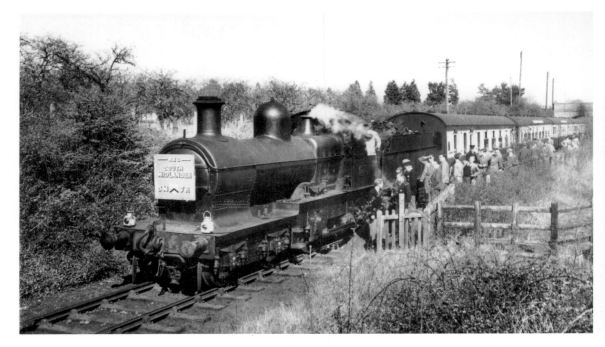

90XX class 4-4-0 No. 9015 at the closed Bidford-on-Avon station with the Railway Enthusiasts' Club special 'South Midlander', 24 April 1955. View towards Stratford. No. 9015 was withdrawn in June 1960. *Hugh Ballantyne*

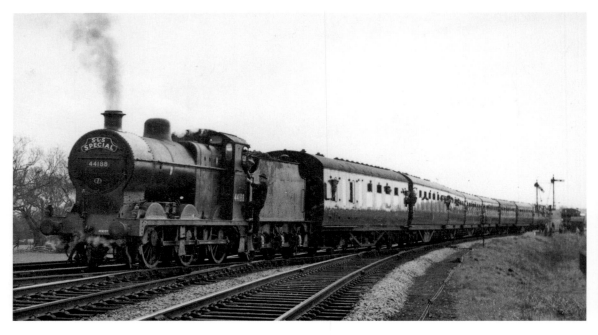

One of the last remaining Class 4F 0-6-0s, No. 44188 (2F Bescot) on a Stephenson Locomotive Society rail tour at Stratford-upon-Avon Curve South Junction, 24 April 1965, entering the new spur to take it to the ex-SMJR station. *W. Potter*

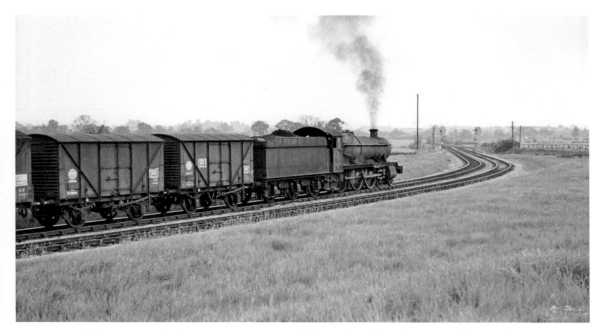

Cardiff Canton Hall class 4-6-0 No. 6944 *Fledborough Hall* with a train of empty banana vans leaves the SMJR at Stratford-upon-Avon, 23 May 1964, and takes the new spur towards Honeybourne. No. 6944 was withdrawn from Oxford shed in December 1965 at the end of steam on the Western Region. The Racecourse station can be seen on the far right. *Michael Mensing*

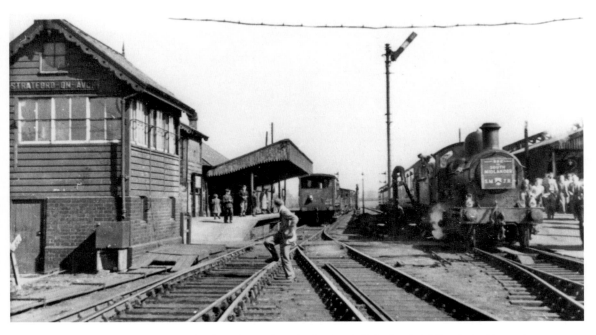

90XX class 4-4-0 No. 9015 hauling the Railway Enthusiasts' Club 'South Midlander' rail tour, has taken water at Stratford, 24 April 1955, and crosses a goods train going the other way. Beyond the signal box in use can be seen an older one. *M. E. J. Deane*

Rail-coach UR 7924 at the Welcombe Hotel, Stratford-upon-Avon, 1932. Passengers are boarding and having their tickets clipped. Notice the off-side door, the railway-type oil headlamps and the luggage being placed on the roof. The doors on both sides require a raised hood to avoid passengers boarding at platforms to avoid striking their heads. *Author's collection*

Rail-coach UR 7924 at the ex-SMJR station, Stratford, before leaving for Blisworth, 1932. Its offside door is open – perhaps for the photographer to make his entrance. *Author's collection*

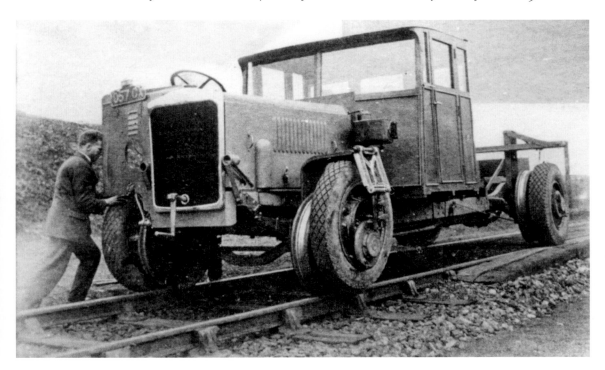

The chassis of LMS Karrier Ro-railer showing the ramp to place it on road or rail. The driver is in the open, while the LMS engineers have shelter. The starting handle would have had a good 'kick'. *Author's collection*

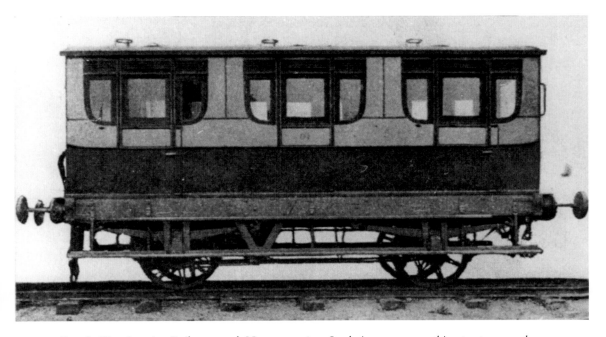

East & West Junction Railway coach No. 01, *c.* 1892. Its design owes something to stage coaches. *Author's collection*

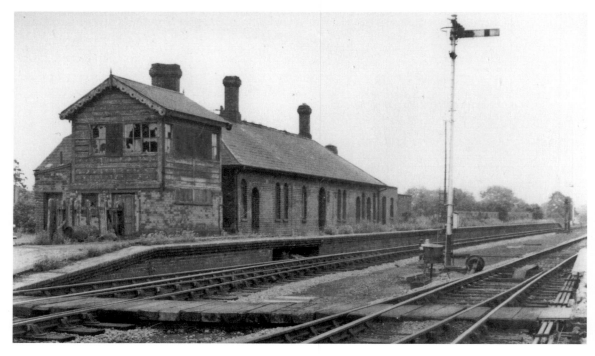

Stratford Old Town station in a derelict condition, *c.* 1961, view east. *Lens of Sutton*

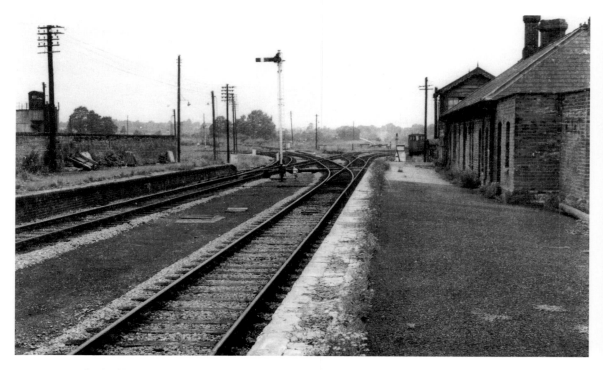

Stratford Old Town station, view west, *c.* 1961. The line on the left leads to Honeybourne and that on the right to Bearley. Straight ahead, now lifted, was the line to Broom Junction. *Lens of Sutton*

"Shakespeare Route."

Stratford-upon-Avon & Midland Junction Railway

On and from Dec. 1st, 1909,

BURTON DASSETT SIDING

(Between Fenny Compton and Kineton Stations;
On main road between Warwick and Banbury)

WILL BE

OPEN TO THE PUBLIC

FOR

Grain, Timber, Bricks, Stone, Coal
and Coke, Hay and Straw, and similar
descriptions of Station to Station Traffic,
in full Truck Loads.

**Goods should be consigned
via S. M. J. Railway, "Shakespeare Route."**

Information respecting Rates and other arrangements
can be obtained on application to the Station Master at
Kineton, or to—

Stratford-on-Avon, RUSSELL WILLMOTT,
Nov., 1909. Traffic Manager.

W. Stanton, Printer, Chapel Street, Stratford-on-Avon.

Right: Notice announcing the opening of
Burton Dassett Siding, 1 December 1909.
Author's collection

Below: Burton Dassett goods station,
c. 1932. Notice the oil lamp, trellis door for
ventilation and the sleeper-walled platform.
An adjacent road bridge caused the shadow
on the left. *Lens of Sutton*

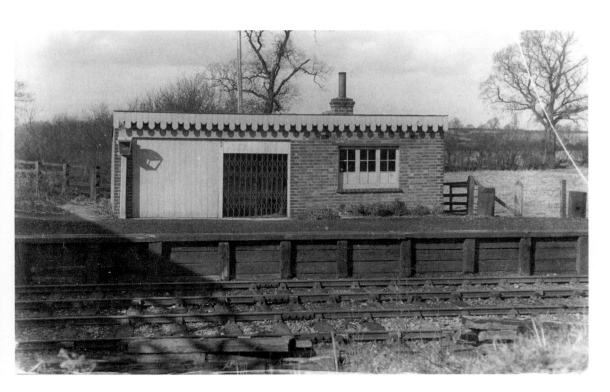

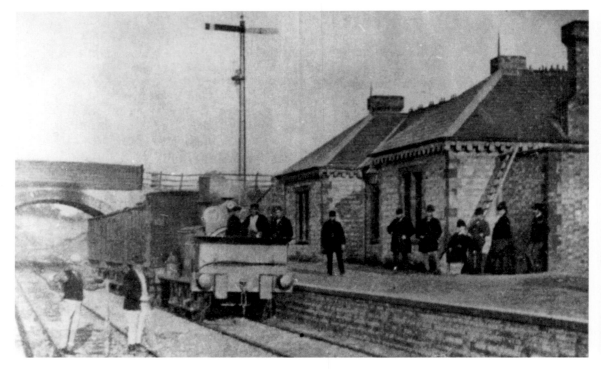

The first passenger train arrives at Kineton station behind 0-6-0ST No. 1, 1 June 1871. Notice that a signal arms for each direction is economically set on just one post. *Author's collection*

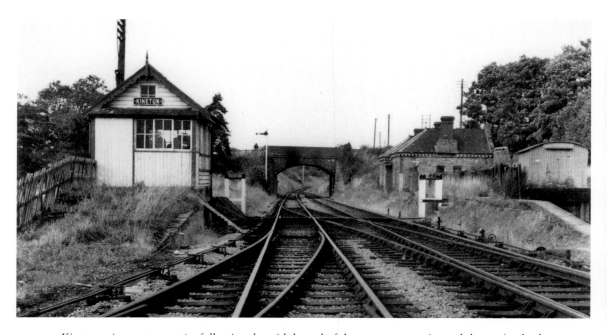

Kineton, view east, *c.* 1960, following the withdrawal of the passenger service and the cutting back of the platform edges. Note the stage, right, built for the signalman to stand on when exchanging the staff. *Lens of Sutton*

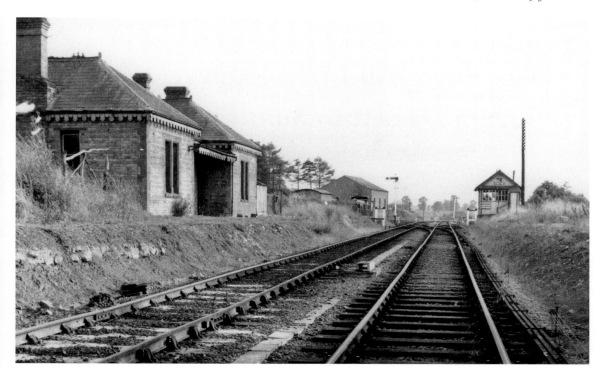

Kineton, view west, *c.* 1960, with the goods shed beyond the passenger station. *Lens of Sutton*

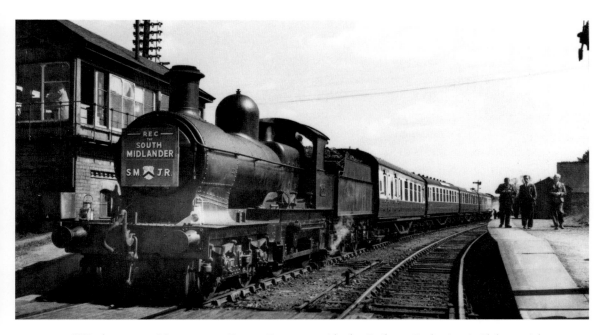

90XX class 4-4-0 No. 9015 at Fenny Compton with the Railway Enthusiasts' Club special, 24 April 1955. *Hugh Ballantyne*

The Edge Hill Light Railway: Burton Dassett to Sunrising

In 1919, a Light Railway Order was granted to build the 5¾-mile-long Edge Hill Light Railway from the SMJR at Burton Dassett Sidings to Nadbury Camp and Sunrising on the top of Edge Hill. The purpose of the line was to carry iron ore. Although an independent company, the chairman of the Edge Hill Light Railway was Harry Wilmott, also chairman of the SMJR, while the chief officers of the EHLR were also those of the SMJR. The chief engineer was Colonel Stephens of light railway fame. Only 4 miles of rail were actually laid and the line opened in 1920. The quarries were worked until 27 January 1925 when the last load was carried, because the aftermath of the First World War had reduced the demand for British ore. A platform built at Burton Dassett for the quarry workers was never used.

Edge Hill itself was ascended by a cable-worked balanced incline half a mile in length. On a gradient of 1 in 9, a descending loaded wagon drew up an empty. There was single track at the lower half of the incline, double track at the midway passing loop and then three rails to the summit, the centre rail being common to wagons in both directions. From the top of the incline the line was level for about three-quarters of a mile.

Most of the EHLR was laid with flat-bottomed rail spiked directly to the sleepers. The bullhead rail used in sidings and elsewhere was mainly set in Hull and Barnsley Railway chairs, though a few came from the SMJR. Curiously the catch points at the foot of the incline were set for the EHLR main line, so in the event of a runaway, the shunter working the incline would have had to dash from his hut across the track to the lever on the other side in order to direct the wagon off the track.

Two locomotives were provided for working the lower level: ex-London, Brighton and South Coast Railway 'Terrier' 0-6-0Ts No. 673 *Deptford* and No. 674 *Shadwell*, which became EHLR Nos 1 and 2 respectively. *Shadwell* had covered 1,165,194 miles before being purchased by the EHLR. Above the incline, trains were worked by No. 3, Manning Wardle 0-4-0WT *Sankey*, built in 1888. It arrived at the top of the incline using its own power assisted by the weight of two descending wagons on the other track. As the EHLR had no engine shed, *Sankey* was able to seek shelter beneath an overbridge. All three engines were scrapped in 1946.

The brake van was an ex-Great Eastern Railway vehicle. The company never exercised its right to carry passengers between Burton Dassett and the foot of the incline. After closure the railway lay derelict for seventeen years until dismantled for scrap in 1942, when the War Department requisitioned a large tract of country near Burton Dassett for a munitions depot. The line had remained intact and unused for three times the length of its operational career. Ministry of Defence sidings still extend from Burton Dassett to Kineton. The site of the EHLR is now overgrown and very difficult to trace.

Label from a wagon of explosives consigned from the Central Ammunition Depot, Corsham, Wiltshire, to Burton Dassett Sidings. It is interesting that although dated February 1962, fourteen years after nationalisation, it refers to the 'LMS Section'.

Edge Hill Light Railway No. 1, ex-LBSCR 'Terrier' 0-6-0T, tarpaulin-covered and out of use. The Westinghouse brake pump can be seen at the rear of the tank. *C. L. Turner*

EHLR track, *c.* 1930: chairs have 'London' cast on. *P. Q. Treloar collection*

The Stratford and Moreton Railway, and the Shipston-on-Stour Branch

Moreton-in-Marsh was the terminus of the horse-worked Stratford and Moreton Railway. Promoted by William James, 'Father of Railways', who was born at Henley-in-Arden, it was part of an ambitous project to link the Midlands with London. Goods were to have been taken to Stratford-upon-Avon by narrow boat, then onwards by tramway to Oxford, reaching London by barge down the Thames. A branch was planned to run via Shipston-on-Stour to Warwick and Coventry; another was to link with the Gloucester and Cheltenham Railway; while a third was to reach the Wilts and Berks Canal. James anticipated that the line would be worked by steam locomotives.

This exceedingly imaginative project was before its time. When the Act was passed on 28 May 1821 the scheme had been whittled down to a line from Stratford to Moreton with a branch to Shipston, while steam engines were specifically banned along public roads near Stratford. The line was constructed under the supervision of Thomas Telford, the great road builder, and was in fact the only public railway ever built by him, though he used temporary lines while carrying out his other contracts. William James travelled widely and saw most of the existing railways in the country. This led him to select the edge rail as being preferable to the plate rail. The 15-ft-long, fish-bellied, malleable iron rails were carried on stone blocks set 3 ft apart. Full width wooden sleepers were placed at irregular intervals to hold them to the 4-ft 8-in tramway gauge. The track may have spread up to an inch. The rails were secured in cast-iron chairs made by Foster, Rastrick and Company of Stourbridge. The line followed the present A34 from Stratford to a point 1½ miles beyond Alderminster, thence cutting across country to Moreton.

Although construction started in 1822, financial difficulties were experienced and the company was hit by rising costs. In June 1825, another Act was passed permitting additional shares to be raised and extending by five years the time allowed for completion. The company's status was harmed when William James had been declared bankrupt in 1824. It happened due to an illness, while in addition his railway activities had caused him the neglect his other business interests. Between November 1822 and August 1834 he spent three spells in debtors' prison. He was dismissed from the company, George Stephenson

being appointed in his stead. James had already introduced Stephenson to the committee, probably as a supplier of engines and plant.

The 16 miles from the present Bancroft Gardens, Stratford, to Moreton opened on 5 September 1826, a poem being specially composed for the occasion:

> Good people all of Moreton town
> Give ear to what I say,
> We all have reason to rejoice
> On this our market day.
>
> To see our iron railway
> It makes one's heart content
> To know what's saved in firing
> Will nearly pay our rent.
>
> So people all, both great and small,
> Who have a little cash,
> Come buy and sell – you may do well
> At Moreton-in-the-Marsh.

The line was worked by horse traction and, although its principal purpose was to carry coal to Moreton and stone and agricultural produce back to Stratford, a passenger service was operated. Although licence fees for carrying passengers were set out in December 1834, passengers had been carried, especially on market days, for at least a year previous to this. The tramway earned an income of about £3,000 a year and with expenses of only about £1,400 was quite a profitable venture for a few years. Goods traffic was conveyed by traders in their own wagons and these traders were permitted to carry passengers on payment of £1 monthly for a licence. Operators could also apply for a licence costing a shilling, which allowed them to travel at 8 mph and overtake slower trains at crossing loops.

Goods depots, using the canal term 'wharves', were located at Alderminster, Newbold, Ilmington, Shipston-on-Stour and Moreton-in-Marsh.

Powers for building the branch to Shipston expired before it could be built, so a new Act had to be passed on 10 June 1833. Shipston-on-Stour was a detached portion of Worcestershire until 1931 when transferred to Warwickshire. On 11 February 1836 the line was finished and opened from Longdon Road, on the main Moreton to Stratford line, to Shipston.

As originally laid, the tramway had passing loops at quarter-mile intervals, so that wagons going in opposite directions could cross. If wagons met between loops, the one that had not passed the distant post 'D' placed midway between the loops, was required to go back. With the relaying in 1853, the track was single throughout, so before noon journeys were restricted to those in the Up direction, and after noon, to Down trains.

Pro bono Publico!!!

Notice is hereby given,

THAT ON

TUESDAY, the 5th of SEPTEMBER next,

MORETON RAIL--WAY

Will be opened for Public use;

ON WHICH DAY,

A GREAT Market WILL BE HELD,

And continued Weekly, agreeable to the Charter,

For the Sale of Corn, Seeds, and all kinds of Grain; also, for Cattle, Sheep, Pigs, Poultry, Meat Butter, Eggs, and Merchandise of every description.

At the particular desire of the many highly respectable Farmers, Dealers, and others, who intend giving this Market their Support, the following Regulations have been determined on, and will be strictly adhered to,--Viz. That all Corn shall be bought and Sold by a *pitched Sample or Bulk;* and that the hours for holding the same, shall commence *precisely at Eleven o'Clock in the Forenoon,* and end at *Two in the Afternoon.*

N.B. A large Wharehouse, nearly in the centre of the Town, will be gratuitously provided by Mr. Hooper, and every accommodation afforded therein for the pitching of Samples, until a more commodious Market House can be erected.

Moreton-in-Marsh, July 24, 1826.

LANE, PRINTER, STOW

Notice advertising the opening of the Moreton Railway, 5 September 1826.

When the Oxford, Worcester and Wolverhampton Railway was built it cut through the Stratford and Moreton Railway's yard at Moreton, so the OWWR took a perpetual lease from 1 May 1847, though the line continued to be managed by its former officers until 1851, when the OWWR arranged to get rid of them and thus reduce its expense.

In the first six years of its existence the branch, which had cost £8,875 to construct, brought in an income of £1,293 against an expenditure of £680. The

OWWR paid an annual rent of £175 for the Shipston branch giving a return to shareholders of a very respectable dividend of almost 2 per cent – far higher than would have been paid had the line remained independent.

In 1853, the tramway from Moreton to Stratford was closed for conversion to raise it to a standard sufficiently high to accommodate main line wagons. It was hoped that this improvement would increase receipts. Unfortunately, this prediction proved inaccurate and annual losses of £400 rose to as much as £1,600 in 1856. When the line reopened, a passenger service was run from Moreton to Stratford twice daily by Mr Bull of the George Inn, Shipston, using an ordinary railway coach adapted for horse traction by fitting a platform at the front which the animal could stand on to ride down an incline. The journey from Moreton to Stratford took about two hours, or one hour to Shipston, all trains travelling via the latter settlement. The first train left about 6.15 a.m. and the second at 4.15 p.m.

This is an abridged version of an article that appeared in the *Stratford-upon-Avon Herald* of 3 June 1904, recounting events which took place in around 1877:

> We spent two or three hours in Stratford and then between 3 and 4 p.m. start back for Shipston. We should not object to a lift if we could get one. We reach the Bell at Alderminster, all right but dry and dusty. Just at that moment a coal truck pulled up from Stratford, en route for Shipston on the Old Tram. 'Will you get up?,' said the driver, William Saunders, a well-known Shipstonian tram-driver, 'You will be welcome if you don't mind sitting on these bricks.'
>
> The driver's old horse, Jumper, went a steady pace. We pulled up at Ilmington Wharf Inn to unload the bricks and take a gentle refresher. It seemed very singular that the landlord's name was Cornelius Gentle, who kept the house. The house stands half-a-mile out of Ilmington, on the side of the Old Tram. Our truck was now empty. 'Twas good sailing'.
>
> We now arrive at a very important point in our journey – Ilmington Junction – where we branch off the main tram line on to the Shipston branch, down a steep gradient by Blackwell Bushes. We pull up. The driver gets off, unhooks Jumper out of the traces, brings him round to the rear of the truck, and shunts a pebble against the front wheel. Jumper seemed to be putting himself into position for something. All at once Saunders let the tail-board down, and to my amazement Jumper bolted up into the truck with the agility of a cat.
>
> Says Bill Saunders, 'Don't you stir an inch, Mister Phelps. As soon as I a' shifted the pebble and put the points right, we shall begin to move.' Afterwards he gave it a push. All at once our truck began to move at a snail's pace. Saunders jumped on the nearside, I was on the off-side, and Jumper was in the middle of the truck, with his head high up in the air. The truck began to go a bit faster. Jumper put his forelegs out an inch or two, so as to take a better standing. We were now going at a fast pace down the incline. Jumper stood up as firm as Ilmington church tower.
>
> All at once in the distance we saw impediments on the line. Saunders found his brake wouldn't act in consequence of our terrific speed. We got near enough to see

it was a farmer with a donkey and cart, and a calf in it a-baaing, and her mother the cow was jumping about on the line after her calf, and the farmer was trying to get donkey, cart and calf down the embankment, but the moke wouldn't stir an inch. The crash was coming when all at once Farmer Cropper of Darlingscott was equal to the occasion. He lifted the tail of the donkey and away went the donkey, cart and calf down the embankment. The cow happened to get out of the road.

Our impetus soon took us by Darlingscott, over the old Fosse Way, and up the deep cutting by the Hut as it is called, and we entered Shipston in good style. After the tailboard of our truck was let down, Jumper twisted round, and jumped out of the truck like a cat.

Several years after poor Saunders met with a fatal accident and slipped under the truck down at Newbold brick-yard, and was killed. I am alone left to tell the tale of our extraordinary outing.

The place where the collision was so narrowly avoided was probably near the site of the later Longdon Road station.

With the opening of the OWWR's Honeybourne to Stratford line in 1859, the tramway service to Stratford was practically forsaken, though a transfer station was created at Longdon Road. The tramway was last used in 1902 and two years later the line was cleared of vegetation and inspected by engineers. The track was lifted for scrap in 1918, it being officially abandoned by Act of Parliament on 4 August 1926, just a month before the centenary of its opening.

Relics of the line can still be seen: the long, multi-arched bridge formerly used by the railway to cross the Avon at Stratford has become a public footbridge and at its Stratford end is Tramway Cottage, formerly the toll house. A wagon preserved in the nearby Bantoft Gardens has the inscription on its wheel centres 'Smith & Willey, Windsor Foundry, Liverpool'. Another reminder of the line is the Old Tramway Inn, Shipston Road, Stratford, which displays a fine picture of a horse-drawn train on its signboard.

The GWR, which had taken over the OWWR, in 1882 laid a short spur at Longdon Road to enable through running to take place from Moreton to Shipston, as before this date through running could only be performed to and from the Stratford direction. Parliamentary powers were obtained in 1882 to bring the Shipston branch up to standard, but then it was discovered that the original 1833 Act forbade the use of steam locomotives. A further Act was therefore necessary and this was passed the following year, but speed was restricted to 20 mph. The improvements included opening out a tunnel north of Stretton-on-Fosse and a new alignment between Longdon Road and Shipston. Curiously enough, right up until the line's closure it was still officially known as the Shipston-on-Stour and Moreton-in-Marsh Locomotive Tramway.

Reconstruction was not rushed and it was not until 1 July 1889 that the line was reopened with four mixed trains running daily in each direction. The *Oxfordshire Weekly News* of 10 July 1889 recorded:

The first train started, amidst great excitement, for Moreton-in-Marsh station, and many visitors arrived to take a first trip on the newly-constructed line, many going only as far as Longdon Road station, and walking back to breakfast. As the train started out of the station the event was announced far and wide by the exploding of fog signals and loud cheers. The opening of the line has come about very suddenly, and proved to be a great and agreeable surprise; several flags were hung out at intervals in different parts of the town as a festive demonstration in connection with the event, and it is expected the opening of the new line will prove favourable to the town and trade of Shipston-on-Stour and a great convenience to the whole neighbourhood.

The branch locomotive was kept in a small, brick-built engine shed at Shipston. Apart from mixed trains, another unusual feature of the branch was that it had no operating signals. The engine shed closed in November 1916, working being taken over by the engine of the morning Worcester to Moreton goods, which shuttled backwards and forwards over the branch, returning every evening to Worcester. The former engine shed was used by the Army for two years, later becoming the garage for the GWR motor lorry used for goods delivery. Another First World War economy was the reduction of the train service from four to two trains daily and the temporary closing of Stretton-on-Fosse station. After the Armistice had been signed, the frequency of trains increased to three daily, Stretton reopening in March 1919. The year 1925 saw three mixed trips still being worked daily. The average daily working on the branch was five loaded coal wagons received, five of general goods forwarded and eight received. As many as 2,793 milk churns were dealt with annually as were 251 trucks of livestock. The annual cost of keeping level crossing keepers on the branch was £212.

Passenger trains to Shipston were withdrawn on 8 July 1929, being replaced by a GWR bus service. Although this took only thirty minutes compared with the forty to forty-five minutes by train, the road service proved uneconomic and was withdrawn at the end of the year. The reason was that traffic flow from Shipston was to Stratford, rather than Moreton, and a bus worked by another operator had run to Stratford since 1914.

The Second World War saw further economies brought about by the closure of the two intermediate stations, but goods traffic to Shipston itself continued, the daily train being allowed one hour thirty-five minutes for the 9 miles to Shipston, and one hour twenty minutes for the return – part of the time being taken up by the train crews having to open and close the gates of the seven level crossings. One Worcester driver, not too familiar with the location of the crossings, ran through a set of gates. His written report stated that when proceeding along the branch tender-first, he ran into a swarm of bees which filled the cab, forcing him and his fireman to quickly vacate it and take refuge in front of the smokebox. Although the swarm eventually dispersed, he and

his mate were unable to return to the cab quickly enough to prevent the train running through the crossing gates.

For many years, due to the branch's light construction, 850 class 0-6-0STs worked passenger and mixed trains, accommodation in 1911 consisting of a solitary eight-wheel brake composite. Certainly from 1940 freight trains were worked by Dean Goods 0-6-0s, but latterly a BR Standard 2MT 2-6-0 from Kingham shed worked the turn. Goods services on the branch were withdrawn on 2 May 1960.

The stations on the branch were unusual for the fact that their timber buildings had outside frames. Shipston, being the principal station, was suitably dignified with a platform canopy sporting deep drip boards, the other two stations not having this refinement.

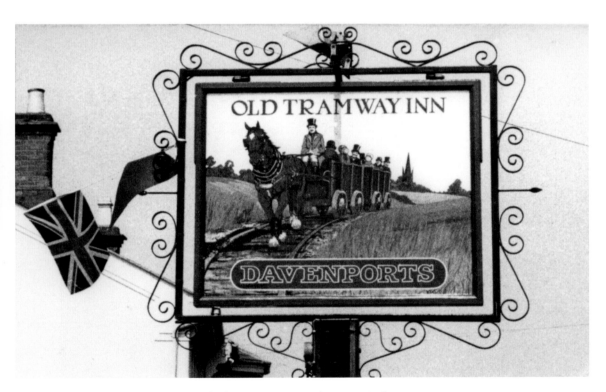

Inn sign, Shipston Road, Stratford-upon-Avon, 30 July 1981. *Author*

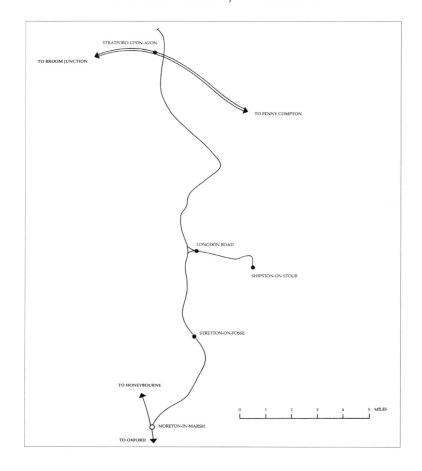

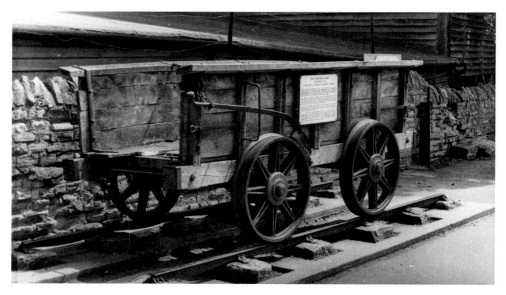

Stratford & Moreton Railway wagon preserved in Bancroft Gardens, Stratford, 30 July 1981.
Author

Bridge across the Avon at Stratford, 30 July 1981. Now a footpath, it was originally used by the Stratford & Moreton railway. *Author*

The former tramway stables at Moreton-in-Marsh, 30 July 1981. *Author*

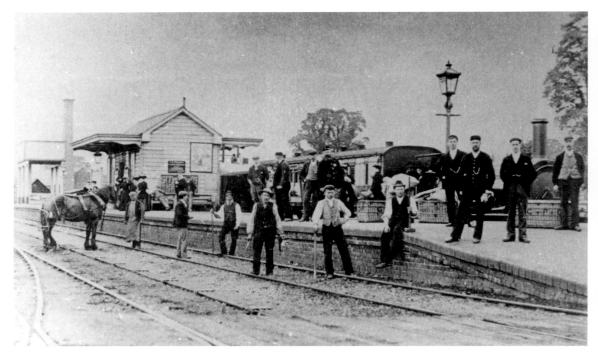

A 517 class 0-4-2T has arrived at Moreton-in-Marsh from Shipston, *c.* 1890. The shunting horse on the main line, left, blocks the Up and Down roads. *Author's collection*

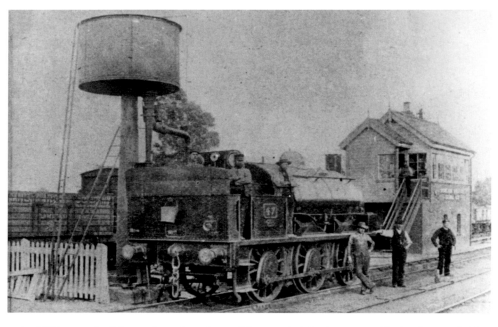

0-6-0ST No. 47, the Shipston branch engine, at Moreton-in-Marsh, *c.* 1887. Notice that a primitive timber weather board protects the crew, except for their heads, when running bunker-first. It has no roof. The engine was built for the Shrewsbury & Birmingham Railway in 1849. The GWR rebuilt it at Wolverhampton in 1875 and it was withdrawn in 1889. *Author's collection*

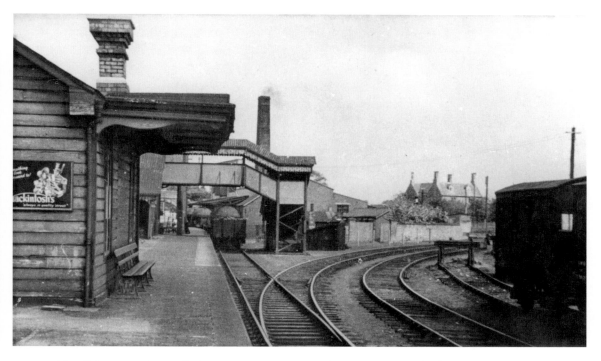

The Shipston-on-Stour platform at Moreton-in-Marsh, 1 June 1947; the branch curves right. *J. Russell*

Mrs White at Todenham Lane Crossing, south of Stretton-on-Fosse, in September 1952, putting out cans for her daily water supply brought by rail. *Author's collection*

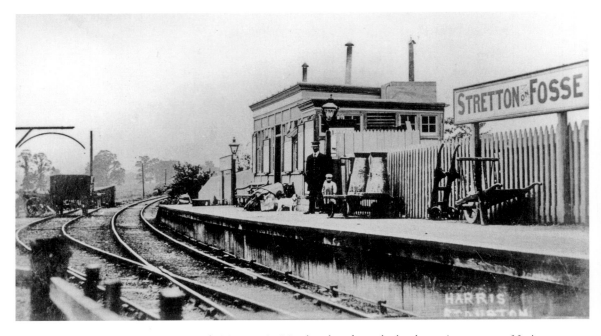

Stretton-on-Fosse view towards Moreton-in-Marsh, taken from the level crossing, *c.* 1905. Notice the wagon in the short siding, the three different varieties of barrows, the seat on the platform and the stationmaster with his son and dog. The timber building has an external water tank. The name board is in white with blue lettering. *Author's collection*

The contractor's lifting train at Stretton, view taken from the A46 level crossing, 11 August 1961. Notice the contractor's locomotive in the distance. *Hugh Ballantyne*

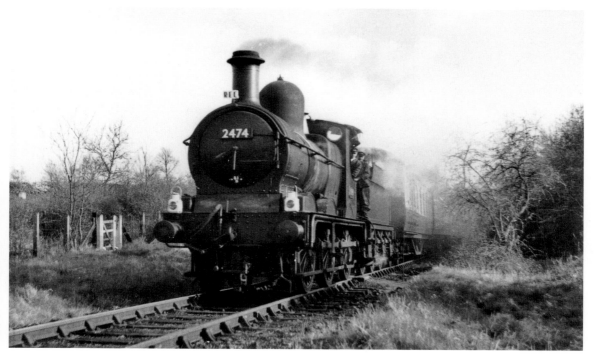

Dean Goods 0-6-0 No. 2474 (81D Reading), heads the Railway Enthusiasts' Club 'South Midlander' between Stretton and Longdon Road, 24 May 1955. No. 2474 was the penultimate Dean Goods in service and was withdrawn the following month. *G. Bannister*

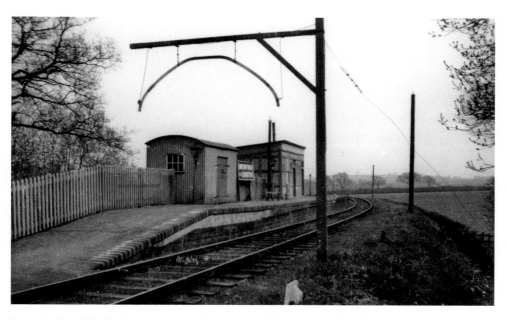

Longdon Road for Ilmington *c.* 1925, view towards Shipston. On the left is a corrugated iron lock-up for parcels. The loading gauge is prominent. *Lens of Sutton*

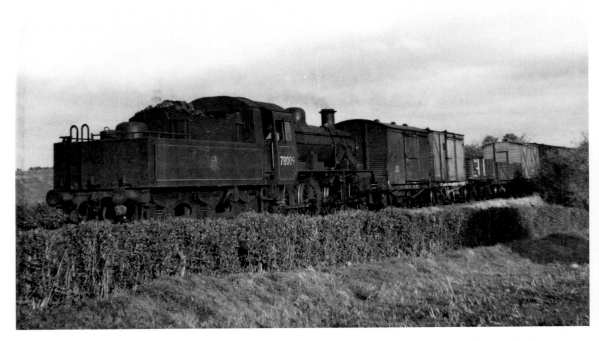

BR Standard Class 2MT 2-6-0 No. 78009 leaving Longdon Road for Moreton-in-Marsh with the twice-weekly freight, 6 October 1953. *G. Bannister*

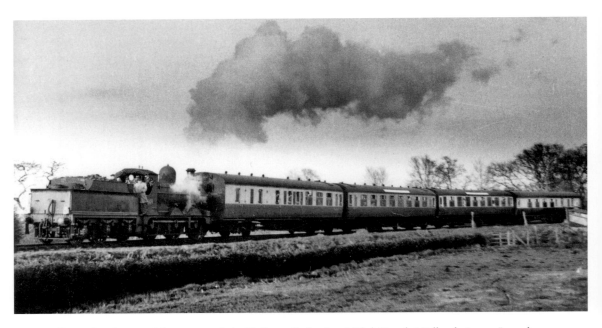

Dean Goods 0-6-0 No. 2474 and the Railway Enthusiasts' Club 'South Midlander' near Longdon Road, 24 April 1955. *G. Bannister*

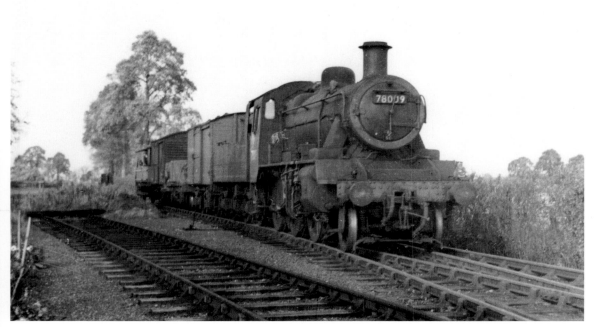

BR Standard Class 2MT No. 78009 (85A Worcester) arrives at Shipston-on-Stour, 6 October 1953, with the twice-weekly goods from Moreton-in-Marsh. *G. Bannister*

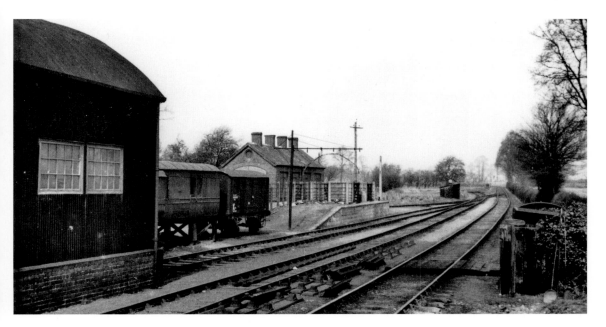

View of Shipston-on-Stour goods yard from the end of the passenger platform, *c.* 1954. The goods shed is on the far left; the loading gauge and cattle pen in the centre; and the former engine shed, which closed in 1923, behind the second van. The first van is grounded, wheelless, while the second is grounded, still with its wheels. *M. E. J. Deane*

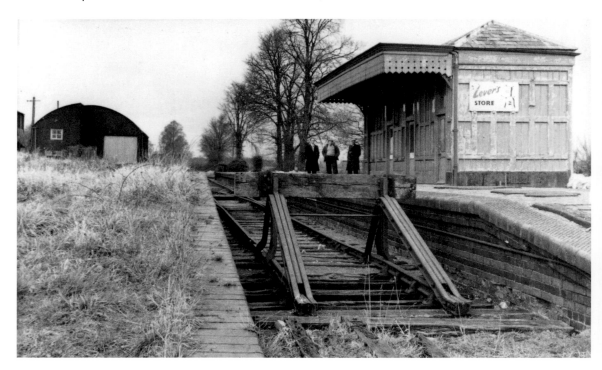

The stop blocks at Shipston-on-Stour, *c.* 1954. The former passenger station is in use as a store for animal feed stuff awaiting distribution. The corrugated iron goods shed is on the left. *M. E. J. Deane*

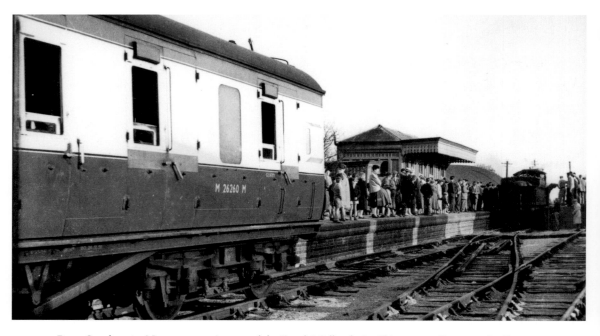

Dean Goods 0-6-0 No. 2474 running round the 'South Midlander' at Shipston-on-Stour, 24 April 1955. *M. E. J. Deane*

Long Marston to Stratford-upon-Avon

The Oxford, Worcester and Wolverhampton Railway's branch to Stratford-upon-Avon from the main line at Honeybourne was authorised by Parliament on 27 July 1846, but due to the difficult state of the money market, the single track standard gauge branch was not completed and opened until 11 July 1859, intermediate stations being at Long Marston and Milcote. When Captain Ross, the Board of Trade inspector, checked the line prior to opening, he found that the chairs holding the rails were only fixed to the sleepers by six-inch wrought-iron spikes. He insisted that within six weeks, the spikes near the rail joints be replaced by fang bolts to obviate the passage of trains over the joints loosening the chairs. On 24 July 1861 the line was extended from its temporary terminus to the GWR's Hatton to Stratford branch, which resulted in through trains running between Leamington, Worcester and Malvern from 1 August 1861.

The GWR, which had taken over the OWWR, contemplated extending southwards from Honeybourne, but no active steps were taken until it was spurred on by the threat of the Andoversford and Stratford-upon-Avon Railway bill, which came before Parliament in 1898. The bill was rejected when the GWR undertook to build a new line from Cheltenham to Honeybourne, which, with the existing branch from Honeybourne to Stratford, promised to serve the district better than a line from Andoversford. Powers for building this new line and doubling the existing branch between Honeybourne and Stratford were obtained on 1 August 1899, thus creating a new line between Birmingham and Bristol. On 10 August 1904 the Great Western Traffic Committee authorised construction of halts at Broad Marston at an estimated cost of £28 and £46 at Chambers Crossing; both opened on 17 October 1904. A steam railmotor service was inaugurated on 24 October 1904, with the two motors stabled at Stratford. One operated mainly to Birmingham and the other to Cheltenham and Evesham. They remained at Stratford shed until August 1917. Both halts closed on 14 July 1916.

Doubling the branch from Honeybourne to Stratford was carried out by Messrs Walter Scott and Middleton, the stations at Milcote and Long Marston being rebuilt. The heaviest work was the building of a new 140-yard-long viaduct over the Avon near Stratford. The railway became a main line when a service of express passenger trains began on 1 July 1908 from Birmingham to

Bristol; the fastest train covered the distance of 98 miles in two hours thirty-five minutes. Stratford Racecourse station, used only on race days, opened on 6 May 1933 and closed on 21 March 1968.

As mentioned on page 77, on 24 April 1960 a new junction south of the Racecourse station was opened at Stratford to enable iron ore trains to run over the line en route from Banbury to South Wales. After the diversion of most inter-regional traffic by 8 November 1965, the only regular traffic over the Stratford line was three freight and two parcels trains, the stopping service being withdrawn on 3 January 1966. The line from Cheltenham to Honeybourne, and Long Marston to Stratford, was closed on 1 November 1976, leaving Honeybourne to Long Marston as a long siding.

The Long Marston site, still connected to the national network at Honeybourne, is operated by Motorail Logistics, which specialise in providing storage for off-lease rolling stock on 15 miles of sidings.

The Shakespeare Line Promotion Group is pressing for a single track reinstatement beside the greenway footpath to boost tourism and help reduce traffic in the surrounding villages. Four train operators have expressed interest in providing services on the line.

Network Rail GW Route Utilisation Strategy mentions a very long term possibility of re-assimilating the Stratford to Cheltenham route as a strategic freight route.

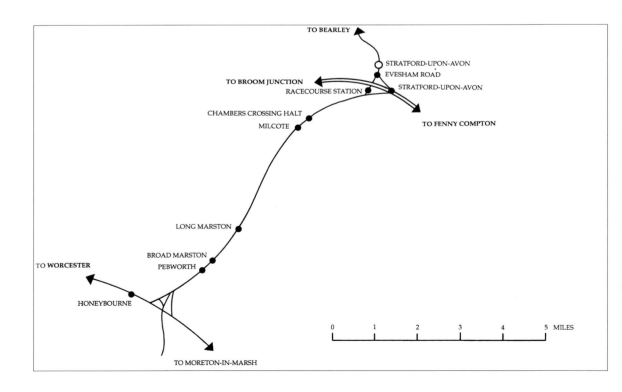

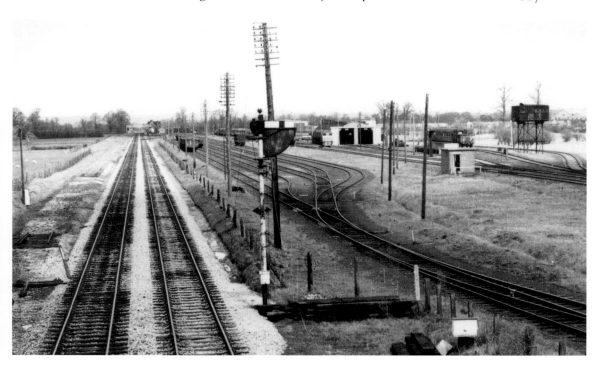

The Ministry of Defence depot, Long Marston, 19 April 1968. The locomotive shed and water tank are on the right. Long Marston station is in the distance. *Author*

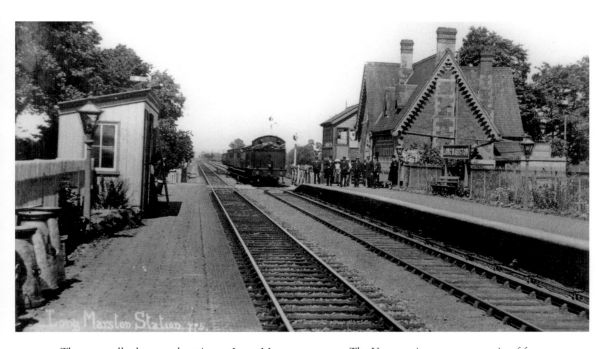

The unusually decorated station at Long Marston, *c.* 1910. The Up stopping passenger train of four or six-wheeled coaches is probably headed by a 36XX class 2-4-2T. Station staff outnumber the passengers. *Author's collection*

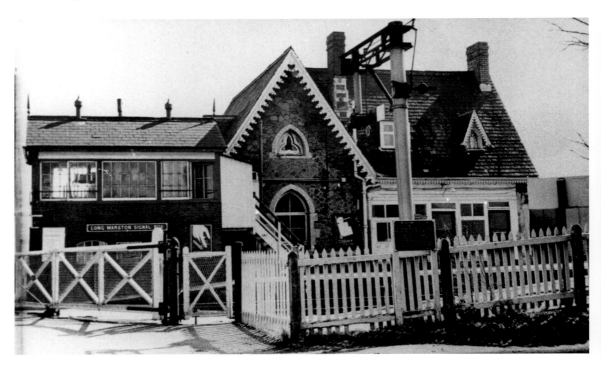

Long Marston station, *c.* 1954. The triangular window is unusual. Notice the signal arm to the right of centre. Unusually placed below the gantry, this is to aid sighting. *Author's collection*

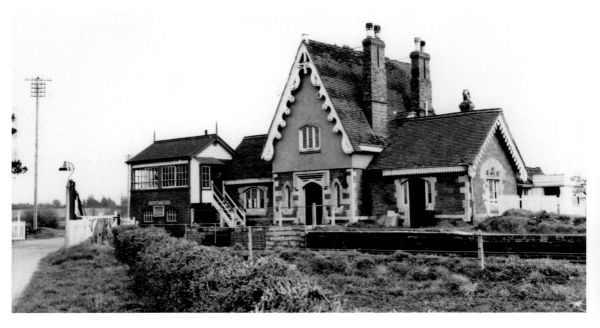

The original Milcote station, 19 April 1968, built to serve a single line. It is similar, but not identical, to the building at Long Marston. *Author*

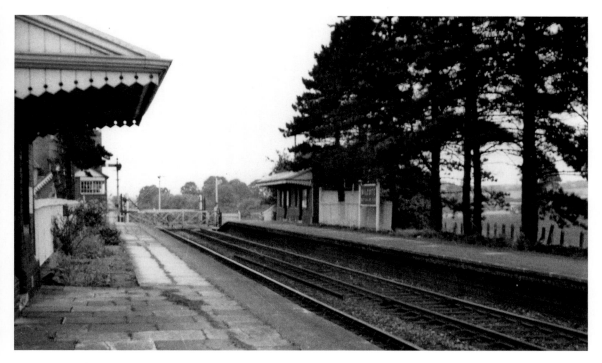

The new station at Milcote, sited just north of the original, opened on 9 May 1908. It closed 3 January 1966. This view looking in the Up direction was taken about 1963. The station was unusual in having trees growing on the platform. *Lens of Sutton*

An engineer's inspection saloon in 1908 on the new 140-yard-long viaduct across the Avon, near Stratford. *Author's collection.*

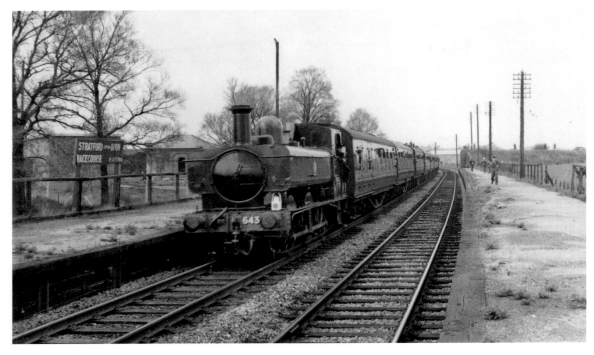

64XX class 0-6-0PT No. 6435, restored to GWR livery, on a special train at Stratford-upon-Avon Racecourse, 24 April 1965. No. 6435 is now preserved. *W. Potter*

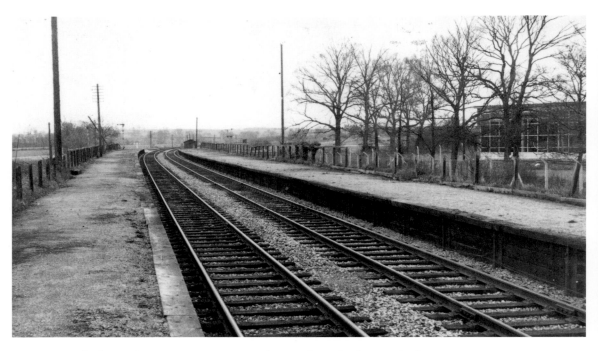

Stratford-upon-Avon Racecourse station, view south, 19 April 1968. *Author*

Stratford-upon-Avon Racecourse station, 19 April 1968: a close-up showing the construction of the platform-facing, second-hand sleepers supported by Barlow rail. *Author*

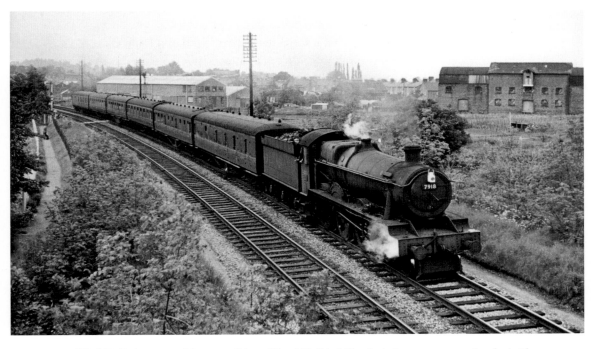

Modified Hall class 4-6-0 No. 7918 *Rhose Wood Hall* (2A Tyseley) about to pass under the bridge carrying the SMJR south of Stratford-upon-Avon, 23 May 1964. *Michael Mensing*

Hatton to Stratford-upon-Avon

The Stratford-upon-Avon Railway was incorporated on 10 August 1857 to build a line from the Birmingham and Oxford Junction Railway at Hatton through to Stratford. It was formerly opened as a single mixed gauge line on 9 October 1860 and to the public the following day. Worked by the GWR, it was absorbed on 1 July 1883, the GWR paying £135-worth of Great Western ordinary stock for £100-worth of Stratford. From 1 January 1863 all regular trains on the branch were standard gauge, but the broad gauge metals remained for a further six years and may have occasionally been used by special trains. With the creation of the new route from Birmingham to Cheltenham early in the twentieth century, double track from Bearley to Stratford was brought into use on 9 December 1907.

The GWR having two termini at Stratford-upon-Avon proved inconvenient and a link was called for. This twenty-nine chain line opened on 24 July 1861 when excursions were run to a military review at Warwick. Seven days later a through passenger service was operated, linking Leamington with Worcester via Stratford and Honeybourne.

The Birmingham Road terminus at Stratford, a timber-built train shed, was closed to passengers on 1 January 1863 as the line had been extended across the Stratford-upon-Avon Canal to a new station shared with the branch from Honeybourne. Birmingham Road continued to be used by goods traffic until 6 May 1968. The new station was Italianate in design with a hipped, overhanging roof in Brunel's early style. Later-pattern awnings were added over the platforms, probably in 1899 when the station was enlarged and a footbridge erected in connection with the extension to Cheltenham. Stratford became a terminus in 1976, and what had once been a main line station was relegated to a branch terminus. Stratford-on-Avon station was renamed Stratford-upon-Avon on 18 June 1951.

A timber-built one-road engine shed sited immediately south of Stratford station opened on 1 January 1863, and with an 0-4-2T as its usual occupant closed in October 1910, when a new two-road brick depot opened to the north. This had an allocation of four engines on 31 December 1947 – two 22XX class 0-6-0s and two 3150 class 2-6-2Ts. The shed closed in September 1962.

In 1908, the curve across the canal bridge was eased, the former line becoming the Down goods loop. Leaving the station, trains faced a rising gradient of 1 in 75 for 1¼ miles, some trains seeking banking assistance to Wilmcote.

South of Wilmcote a tragic accident occurred on 24 March 1922. A Stella class 2-4-0 was working tender-first from Stratford to turn on the triangle at Bearley. South of Wilmcote the driver felt a bump. Stopping to investigate the cause, he was horrified to see four bodies on the Up line. They proved to be a sub-ganger, underman and two platelayers. They were buried in a common grave at Wilmcote, over 200 railwaymen attending their funeral.

Wilmcote originally had a single platform and to the north a mineral line ran to the Blue Lias Lime and Cement Works. A new double track station nearer Stratford and south of the overbridge was opened on 9 December 1907. At Bearley West Junction the branch curved eastwards from the Tyseley line and reached Bearley Junction and the two-road station. In 1939, rather unusually for a country station, its lamps were electrified. The passenger platforms were shortened at both ends to 200 ft on 10 December 1966. The platform canopy supporting brackets each bore a small shield with the letters 'SA' indicating Stratford-upon-Avon Railway. From the far end of the passing loop the track was doubled to Hatton on 2 July 1939, but reverted to single on 12 January 1969, only one platform remaining in use. Today the station has a bus stop type shelter.

Claverdon, not a block post, originally had a single platform and goods siding, later to become a goods loop. On doubling, the original passenger station was closed and replaced by a new one west of the overbridge. The 1930s style offices still remain at road level, though disused, and a waiting shelter in similar style is on the now single platform.

Just before reaching the main line at Hatton, North Curve (forming a triangular junction and giving a direct run towards Birmingham) came into use on 1 July 1897. This Curve was singled on 22 September 1968 in preparation for takeover by Saltley Power Box.

Hatton station has two through main lines, the Down platform is an island and branch trains use its outer face. At one time the Down platform had a refreshment room, but today all the GWR buildings have been razed and there is a grey brick building on the Up platform and a bus stop type shelter on the island platform. Goods traffic at Hatton was chiefly fertilisers, animal feeding stuffs and livestock. The locomotive turntable was removed in 1913.

The number of trains has shown very little alteration over the years:

Year	Weekdays	Sundays	Approximate time in minutes Hatton – Stratford
1887	9 Up, 8 Down	2	25
1910	10 each way	2	20
1922	10 each way	3	20
1938	13 each way	6	19
1993	9 Up, 8 Down	5	12
2011	9 Up, 8 Down	5	25

In 1951, the 'William Shakespeare' express was introduced, one of five titled trains to use the first BR Standard coaches. The main part of the train ran from Paddington to Wolverhampton, but three coaches were uncoupled at Leamington and taken on to Stratford, often by 2-6-2T No. 4112. The venture was a commercial flop and the title vanished at the end of that summer service.

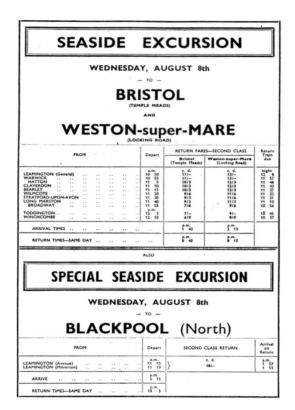

Left: An extract from a 1956 excursion handbill.

Below: Instructions contained in the *Appendix to the Working Time Table,* October 1960.

STRATFORD-ON-AVON.

Accommodation Crossing to Mr. J. H. Rowe's Farm, near Goods Shed:—

The Guards and shunters, or the driver in case of a light engine, must see that this crossing is kept clear, and that no vehicle or person is crossing or about to cross BEFORE any shunt is made over the crossing. The persons using this crossing have instructions when any horse-drawn vehicle is crossing the railway that the horse must be led, and the staff must see that this practice is strictly carried out and report immediately any case where it is not done.

Messrs. Lucy & Nephew's Siding:—

Before a shunt is made from the Goods Shed sidings to this siding across the approach road, the guard or shunter must get the key to the padlock of the scotch block from the signal box, and must see that the crossing is clear before any movement is made with the engine or vehicles across the approach road. When the shunting is completed the scotch blocks must be placed across the railway and secured with the padlocks provided for the purpose, and the key returned to the signal box.

No shunt must be made in either direction across the approach road when a passenger train is due to arrive at or depart from the station.

Public Footpath leading to Allotments and Racecourse:—

The guards and shunter must see that A CLEAR CROSSING is kept at this point, and that no one is crossing or about to cross the line BEFORE any shunt is made over the crossing.

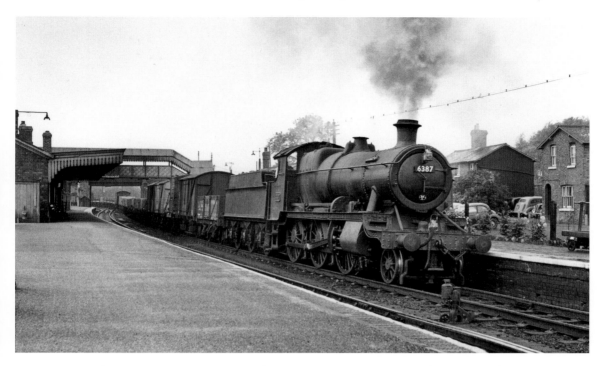

43XX class 2-6-0 No. 6387 (84C Banbury) passes Hatton, 23 September 1957, with an Up freight from the Bearley branch. No. 6387 was withdrawn from 85A, Worcester in June 1962. *Michael Mensing*

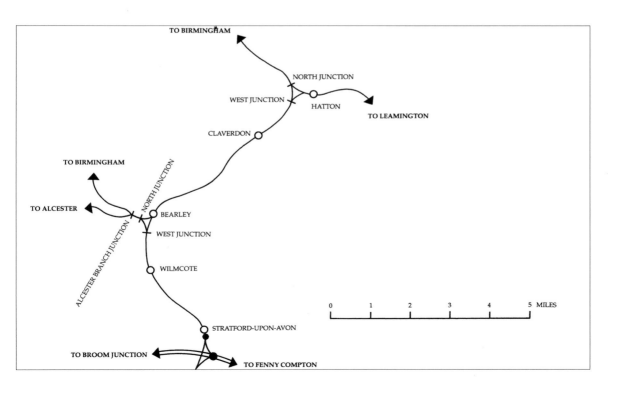

The decorated barrow and spade used for the ceremony of turning the first turf of the Stratford-upon-Avon Railway on 19 February 1859. *Courtesy:* Illustrated London News

BARROW AND SPADE USED IN CUTTING THE FIRST TURF OF THE STRATFORD-ON-AVON RAILWAY.

On Tuesday week, as recorded in the last Number of this Journal, the first turf of the long-projected railway between Stratford-on-Avon and Hatton was turned at the former place amid great rejoicings. We give an Engraving of the elegant wheelbarrow used on the occasion. It is made of oak, in the form of the navvy's barrow, but managed so as to bear the Elizabethan character, and is literally one mass of rich carved work. The wheel resembles the marigold windows of the Gothic; the front over the wheel has a well-executed relievo, in bronze, of the head of Shakspeare; the sides of the barrow are filled with labels or scrolls, having quotations from the various works of the immortal bard; and the back is enriched with roses and thorns, suggestive of the pleasures and anxieties of life. The handle of the spade is also of oak, the head being of a heart-shape form, in steel, silvered, and bearing the inscription, "Stratford-on-Avon Railway." The shaft has scrolls running round, with quotations similar to the barrow. The barrow and spade were designed and executed by Mr. John Thomas, of Alpha-road, London.

The *Illustrated London News* report of the turf turning ceremony.

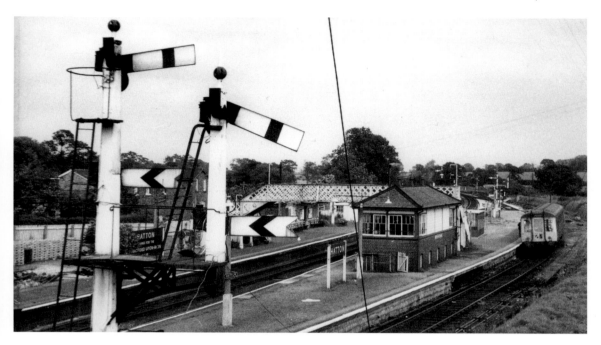

Hatton, view Up, 27 August 1969, with a single car Gloucester Railway Carriage & Wagon Works DMU for Stratford. *D. Payne*

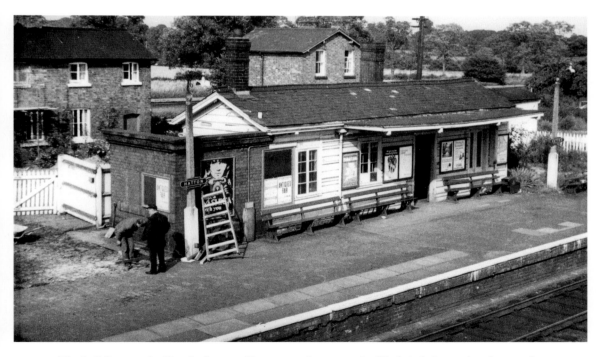

The building on the Up platform at Hatton, 27 August 1969. Work is being undertaken to the surface of the platform near the entrance gate. At the right-hand end of the furthest seat are movable steps to ease the passage of disabled passengers. *D. Payne*

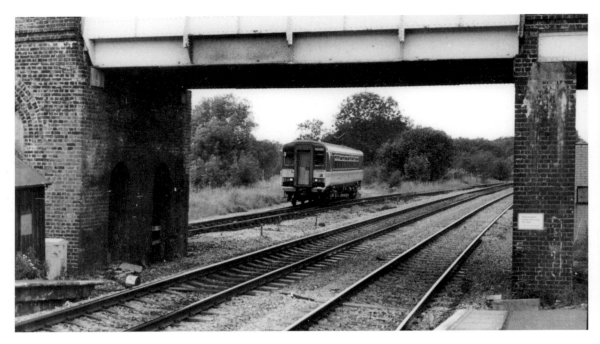

Leyland Super Sprinter No. 153311 leaves Hatton as the 14.35 Leamington Spa to Stratford-upon-Avon, 14 August 1993. *Author*

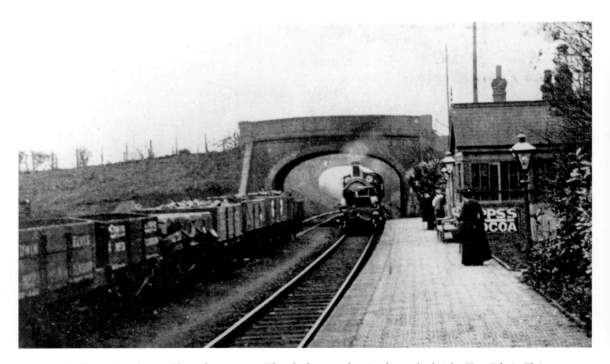

An Up train arrives at Claverdon, *c.* 1905. The platform surface is of non-slip bricks. Two Edwin Elvis coal wagons are in the siding on the left. This card was postmarked 19.8.08. *Author's collection*

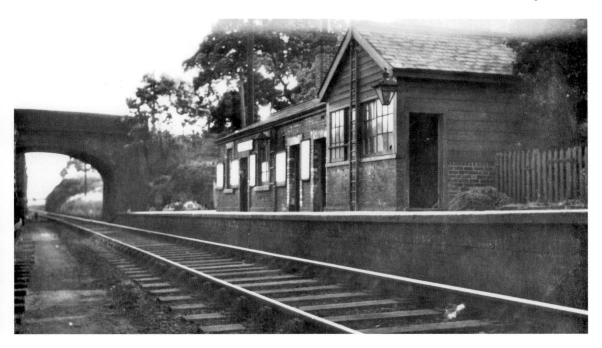

Claverdon, view Down, *c.* 1925, before the new platforms were opened on 2 July 1939. The ladder is stored out of use. *LGRP*

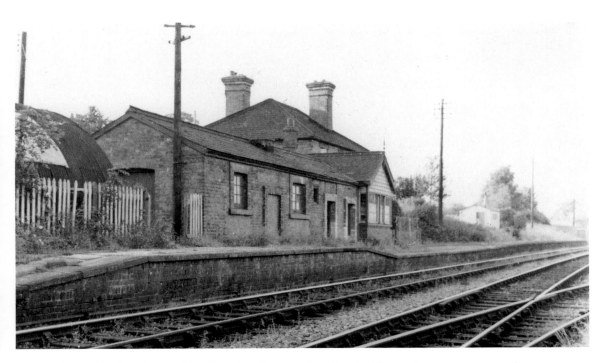

The original station at Claverdon, view Up, *c.* 1960, after doubling and conversion to goods use. *Lens of Sutton*

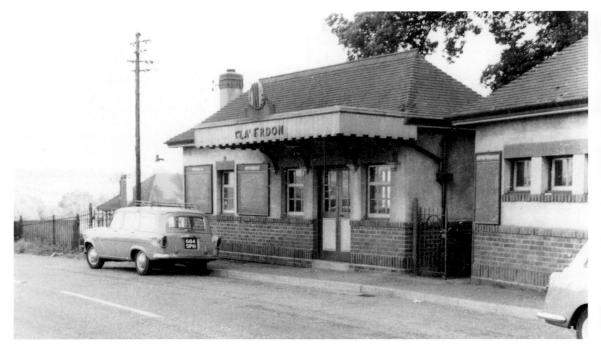

The unusual road level offices of Claverdon station, *c.* 1960. Notice the GWR roundel on the roof. The vehicle is a Standard Vanguard shooting brake. *Lens of Sutton*

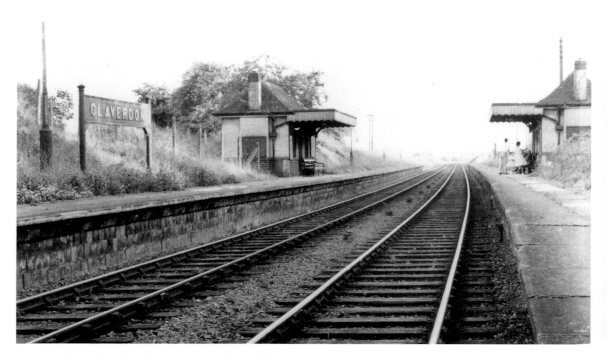

Claverdon, view Down, *c.* 1960. *Lens of Sutton*

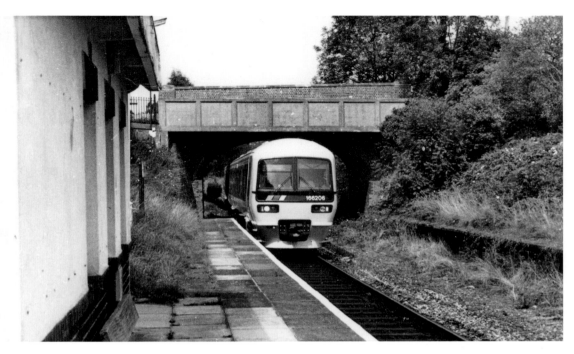

Network Express Turbo No. 166206 rushes through Claverdon, 14 August 1993, with the 14.30 Oxford to Stratford. *Author*

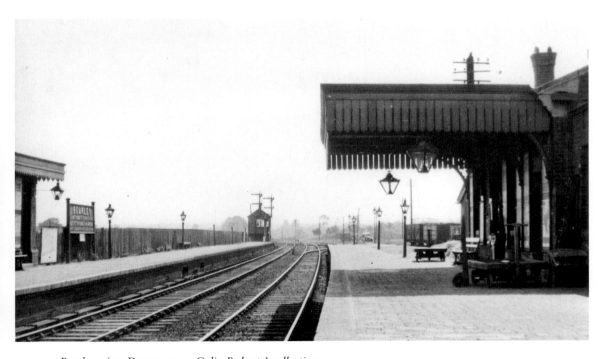

Bearley, view Down, 1934. *Colin Roberts' collection*

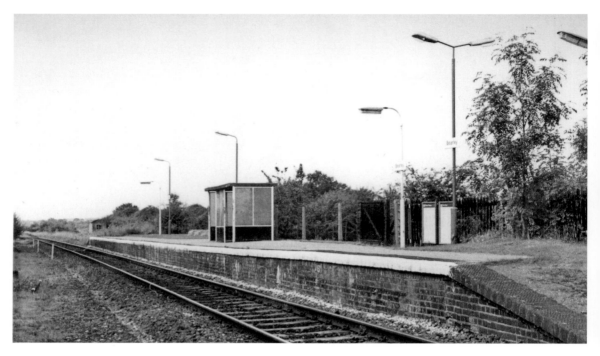

Bearley, view Down, 14 August 1993. *Author*

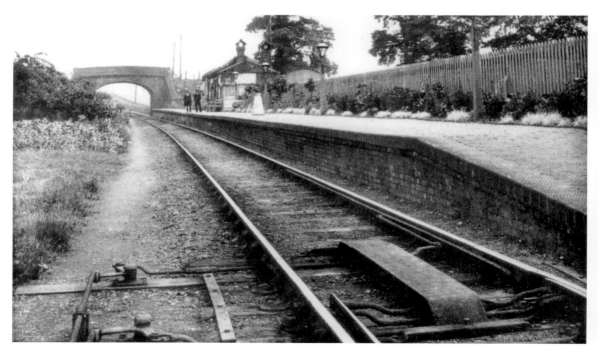

The original station at Wilmcote, view south, before doubling, *c.* 1906. Only one milk churn stands on the platform. The station garden is a credit to the staff. Points for the siding are in the foreground. The chimney cowl is unusual. The cement works are on the far right. *Author's collection*

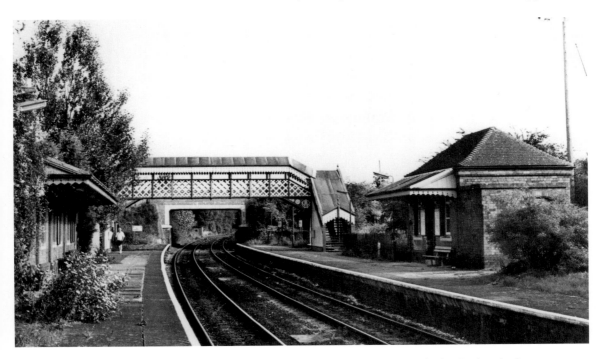

Wilmcote, view Down, 14 August 1993. Notice the GWR monogram on the footbridge. *Author*

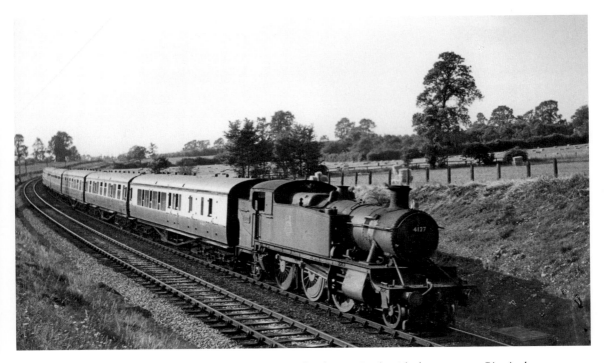

5101 class 2-6-2T No. 4127 starts the descent of Wilmcote Bank with the 5.05 p.m. Birmingham (Moor Street) to Stratford-upon-Avon, 15 June 1957. *Michael Mensing*

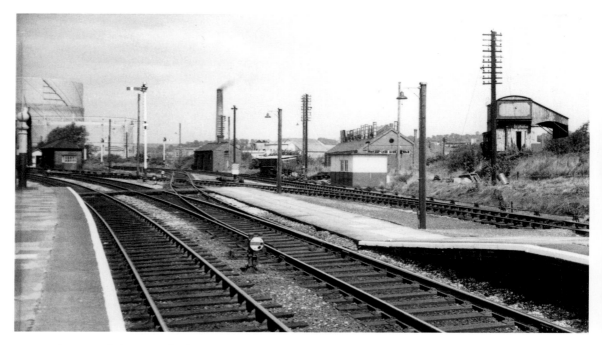

View north from Stratford-upon-Avon station, 27 August 1969. Centre right is the locomotive shed closed in September 1962, with the coaling stage and water tower on the far right. *D. Payne*

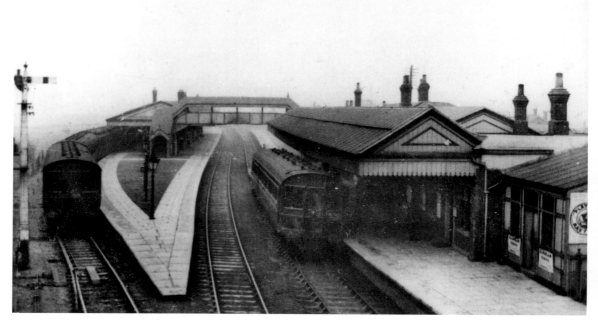

Stratford-upon-Avon view north, *c.* 1916. Steam rail motor can be seen right and auto trailer left. Note the trap point, lower left. *Author's collection*

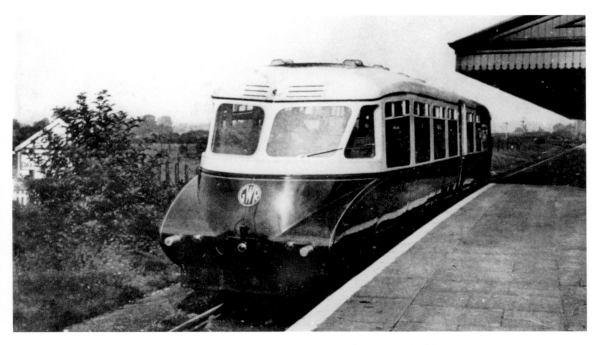

Streamlined diesel railcar at Stratford-upon-Avon, *c.* 1935, having worked from Leamington Spa. This batch of railcars was without draw gear or standard buffers. *Author's collection*

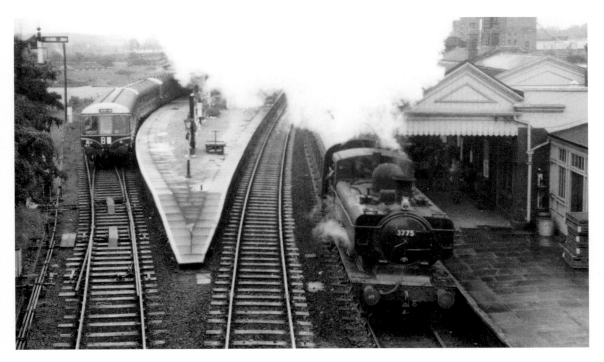

8750 class 0-6-0PT No. 3775 (85A Worcester) at Stratford-upon-Avon, 21 August 1958, with a train to Worcester. A DMU to Leamington Spa is on the left. *R. E. Toop*

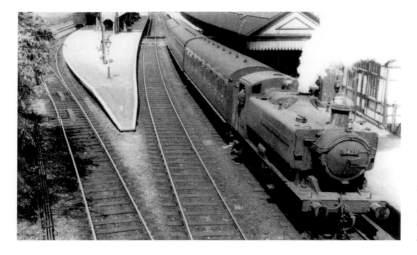

94XX class 0-6-0PT
No. 9429 (85A Worcester)
at Stratford-upon-Avon,
c. 1958.
Author's collection

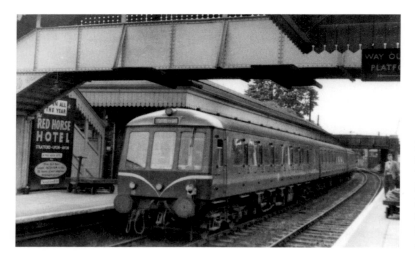

Derby Works 3-car
suburban DMU
W50119/59020/50057 at
Stratford-upon-Avon, 31
May 1958, with the 10.10
a.m. from Birmingham
(Moor Street).
Author's collection

The end of the line
just south of Stratford-
upon-Avon station,
14 August 1993. Formerly
this was the main line to
Honeybourne and the
south. *Author*

Wilmcote to Shirley

As mentioned in the Long Marston to Stratford chapter, early in the twentieth century the GWR created a new main line from Birmingham to Bristol using new and existing lines. One of the principal new lengths of track was that from Tyseley to just south of Bearley where it linked with the existing Hatton to Stratford branch.

The Birmingham, North Warwickshire and Stratford-upon-Avon Railway received its Act on 25 August 1894 to build an independent line from Birmingham Moor Street to Stratford. This line was closely associated with the Great Central Railway, which had running powers over the East and West Junction Railway to Stratford. Following an agreement between the GCR and the GWR, plans for the BNWSR were amended by an Act of 9 August 1899 for a line from the GWR's existing line just south of Tyseley to just south of Bearley. The BNWSR's powers were transferred to the GWR by Act of 30 July 1900.

The contractors C. J. Willis and Son cut the first sod at Henley-in-Arden on 5 September 1905. Employing twenty-three locomotives and eleven steam navvies they made such excellent progress that in November 1906 GWR directors and senior officials were carried by contractor's train from Bearley to Tyseley. The principal engineering feature was the 175-yard-long tunnel at Wood End. Most of the stations were of brick, the only stone bridge on the line being north of Danzey. It crossed a drive leading to Umberslade Hall, and in order to secure the passage of the railway through this estate the drive had to be crossed by a bridge of three elliptical arches, built of stone in order to match that of the house. The fact that the bridge was on the skew combined with the elliptical arches made the task difficult, as each stone had to be cut separately and hardly any two were alike.

North of Henley a cutting was made wide enough for four lines. It was not anticipated that the track would need quadrupling, but it was widened after completion in order to provide material for finishing embankments in the neighbourhood. The BNWSR opened for goods traffic on 9 December 1907 and to passengers on 1 July 1908.

Although the line was primarily built for through traffic, it had possibilities of commuter housing development. Today the line is no longer a through route,

and it is passenger traffic from these stations that has kept it open, for the last freight trains on the line were withdrawn on 6 May 1968, when the twice-weekly Bordesley to Stratford and back was abolished. During autumn 2010 the semaphore signalling between Tyseley and Stratford-upon-Avon was replaced by colour lights controlled by the West Midlands Signalling Centre, Saltley.

The initial local passenger service was provided by steam railmotors, and on most trains Birmingham passengers were required to change at Tyseley. By April 1910, the Tyseley to Stratford service consisted of six Up and seven Down, plus thirteen short workings terminating at Bearley, Henley, Earlswood Lakes and Shirley. On Sundays there were four each way from Tyseley to Henley and one for Danzey. By July 1922, the development of commuter traffic had its effect and the timetable showed eleven trains each way and twenty-three short workings, and on Sundays two through trains and five short workings. The service was even more intensive in July 1938 with twenty-nine each way and twenty-six short workings, while on Sundays there were fifteen Up and thirteen Down, plus four short workings Up and five Down. From 6 October 1975, a half hourly service was introduced between Birmingham and Shirley, with an hourly service through to Stratford. In the summer of 1993, fifteen trains ran each way from the recently reopened Birmingham (Snow Hill), and five on Sundays. The year 2011 sees 18 each way daily and seven on Sundays. In 1938, a stopping train from Stratford to Shirley took forty-seven minutes, thirty-three in 1993, and thirty-five in 2011.

The double-track Shirley line left the Hatton to Stratford branch at Bearley West Junction and, about half a mile beyond, the Bearley to Alcester branch was joined at Bearley North Junction. After following the branch for 250 yards it diverged at Alcester Branch Junction. The line passed under the aqueduct carrying the Stratford-upon-Avon Canal and beyond the almost unbroken climb begins of 10 miles at 1 in 150 to Earlswood Lakes. Wootton Wawen Platform kept its description 'Platform' until 6 May 1974, and was the last on the former GWR to be so titled. Wawen is pronounced 'Warn'. Henley-in-Arden has one Up platform on which the main building is sited, but the Down platform is an island, the outer platform useful for terminating trains. The Down platform has now lost its canopy and the footbridge, which doubles as a public footpath, is only roofed at the sections between the two platforms. From 1927 an annual outing was made to the station by the Birmingham Poor Children's Fresh Air Fund. Over a thousand children were brought to Henley by train, then played in a field by the station, enjoyed a picnic and on returning to the station were presented with a new penny and a bunch of flowers.

North of the station was the spur put in to link the North Warwickshire line with the Henley branch. The opening of the new passenger station at Henley rendered the terminus of the branch from Rowington Junction redundant, and so was converted to a house for the station-master of the new North Warwickshire station. The yard was retained for goods use until closure on 31 December 1962.

Danzey for Tanworth originally had small corrugated iron waiting shelters on the platforms, but these have now been replaced by concrete shelters. Its goods sidings were taken out of use on 31 July 1964, but no goods shed was provided. It was, and still is, in a very rural situation with just ex-railway cottages close by. The line passes through the 176-yard-long Wood End Tunnel with Wood End station beyond. The station is situated in a cutting and its only approach is by footpath along the top of the cutting, formerly passing a wooden booking office, before leading down to a footbridge giving access to either platform.

Beyond, the stations follow in close proximity. The Lakes Halt, only a mile from Wood End, opened on 3 June 1935, the lakes themselves supplying the Stratford Canal. A sleeper wall still supports the platforms, which were originally timber waiting shelters, but now are of the bus stop type. Less than a mile beyond, Earlswood Lakes stands at the summit of the line and in steam days had a water crane on each platform fed from a water tank on the embankment. A refuge siding was provided for each direction in addition to goods sidings.

The line descends at 1 in 230 for a mile to Grimes Hill and Wythall, simply called Wythall from 6 May 1974. Originally it had a timber-built booking office by the road overbridge, but it is now unstaffed. There was no goods yard. Whitlocks End, a mile beyond and opened on 6 July 1936, was similar in appearance to The Lakes Halt. Just short of a mile further on is Shirley – a principal station originally with Up and Down refuge sidings, goods shed, cattle pen and loading dock. The station did not lose its coal yard until 6 May 1968. It still has a red brick main building on the Up side and today is most attractive with flowers. It was the opening of the North Warwickshire line that led to Shirley's development, as until then it was 3 miles from a railway station and the only contact with Birmingham was by an infrequent and inadequate horse bus service.

Quite a wide variety of locomotive power has been used on local services. In the early days were steam railmotors, 2-4-2Ts and 4-4-2Ts with 2-6-2Ts later. In the 1930s, Duke and Bulldog class 4-4-0s were used on semi-fasts. Later, 51XX, 61XX and BR Standard Class 3MT 82XXX 2-6-2Ts worked until the advent of dieselisation at the commencement of the 1957 summer timetable when Derby-built three-car sets were introduced.

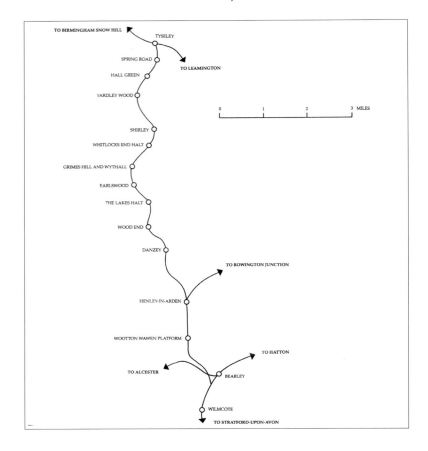

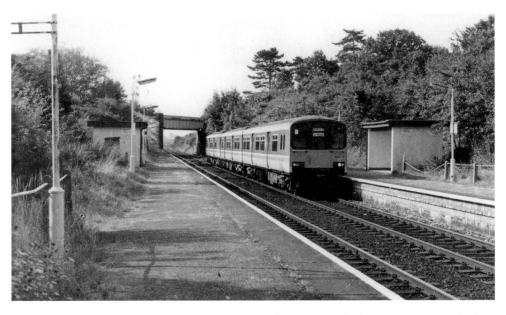

Sprinter No. 150014 arriving at Wootton Wawen with the 09.20 Stratford-upon-Avon to Birmingham (Snow Hill), 14 August 1993. *Author*

Contractors at work at the station site, Henley-in-Arden, 1906. *Author's collection*

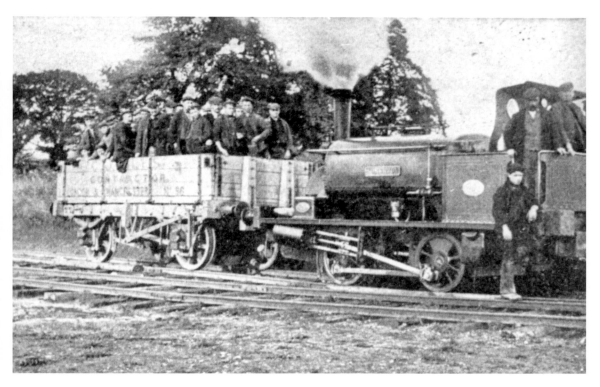

The contractor's train at Henley-in-Arden, 1906. *Author's collection*

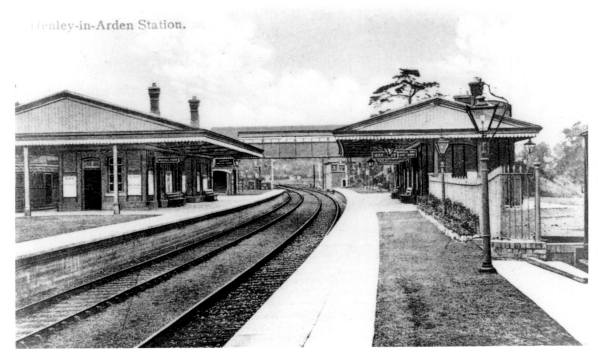

Henley-in-Arden, view Down, *c.* 1910. *Author's collection*

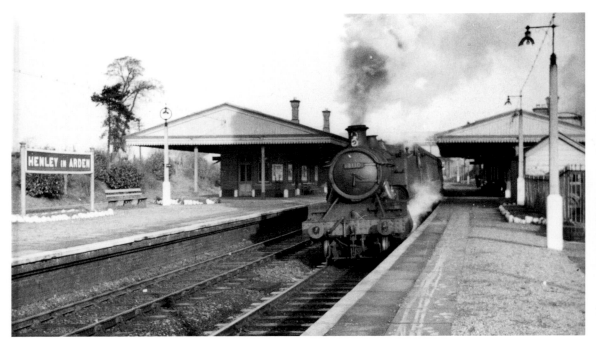

5101 class 2-6-2T No. 4110 at Henley-in-Arden, *c.* 1954, with an Up train. No. 4110 is now preserved. *M. E. J. Deane*

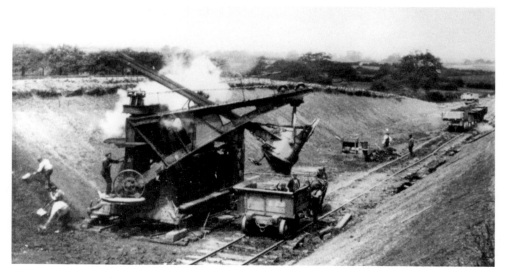

Steam navvy at work north of Henley-in-Arden, 1906. *Author's collection*

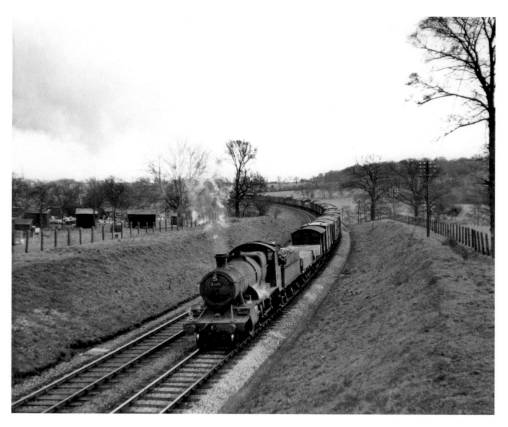

43XX class 2-6-0 No. 5370 slowly plods up the gradient of 1 in 150 towards Danzey station, 25 March 1956, with a train of about fifty wagons. No. 5370 was withdrawn from Llanelly in September 1960. *Michael Mensing*

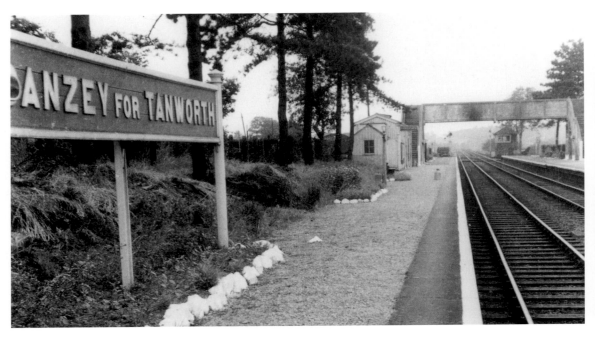

Danzey for Tamworth, view Down, *c.* 1963. Notice the neatly whitewashed edges to flower beds and platforms. *Lens of Sutton*

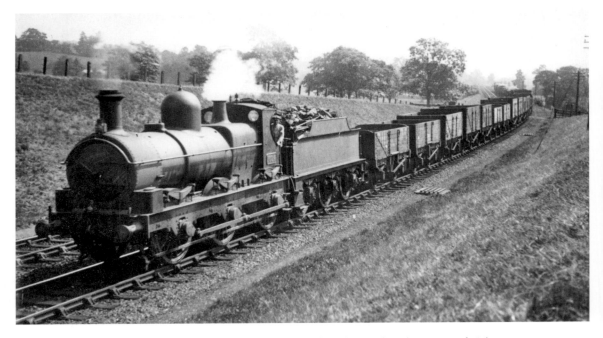

Standard Goods 0-6-0 No. 1094 approaches Wood End Tunnel with a Down freight, *c.* 1926. The sixth and seventh wagons have brake handles on one side only – a nightmare for the guard when pinning down brakes at the head of a gradient, or a shunter when trying to control a wagon. *Author's collection*

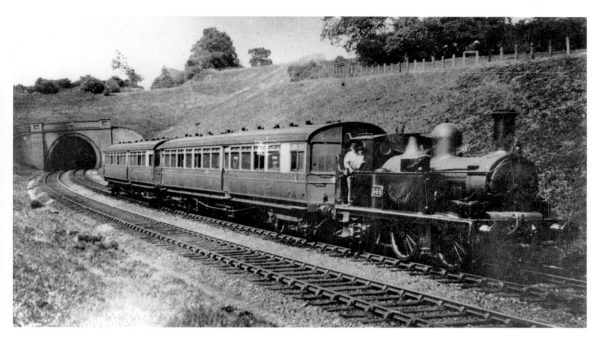

517 class 0-4-2T No. 544 leaves Wood End Tunnel with an Up train, *c.* 1920. No. 544 seems to be still in its First World War black livery. It was withdrawn in October 1928. *Lens of Sutton*

Sprinter No. 150011, working the 10.20 Stratford-upon-Avon to Birmingham (Snow Hill), leaves Wood End Tunnel and enters the station, 14 August 1993. *Author*

Gloucester Railway Carriage & Wagon Works single-car DMU and driving trailer, leaves Wood End with the 1.20 p.m. Henley-in-Arden to Birmingham (Moor Street), 18 May 1963. *Michael Mensing*

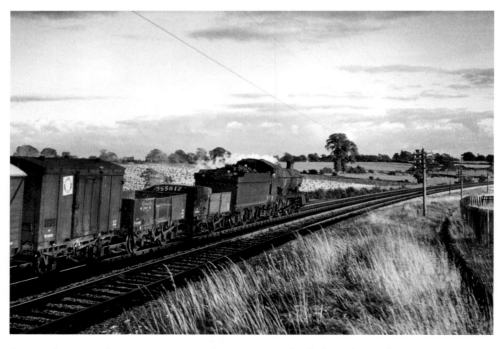

Grange class 4-6-0 No. 6834 *Dummer Grange* just south of The Lakes Halt with an Up freight, 25 August 1962. *Michael Mensing*

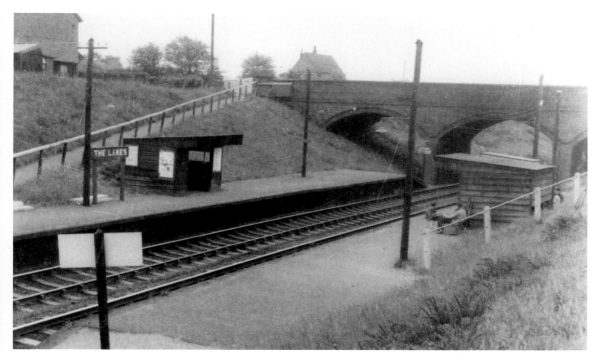

The Lakes Halt, view Down, *c.* 1960. The lads on the Up platform believe in carrying out their railway observation in comfort. *Author's collection*

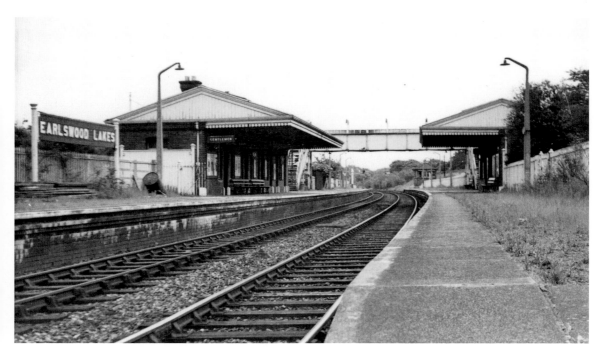

Earlswood Lakes, view Up, 5 June 1968. *D. Payne*

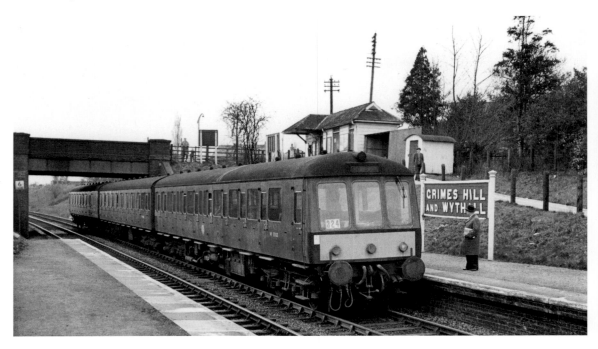

Derby Works three-car Suburban DMU, the leading vehicle Motor Second W50100, arrives at Grimes Hill & Wythall with the 10.35 a.m. Stratford-upon-Avon to Birmingham (Snow Hill), 14 April 1963. *Michael Mensing*

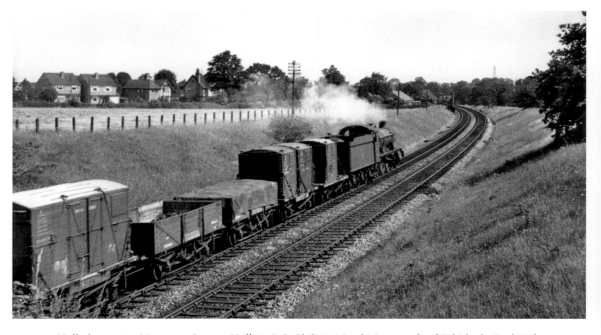

Hall class 4-6-0 No. 4905 *Barton Hall* (82B St Philip's Marsh) just north of Whitlocks End Halt with a Down freight, 8 July 1962. No. 4905 was withdrawn from Didcot, November 1963. *Michael Mensing*

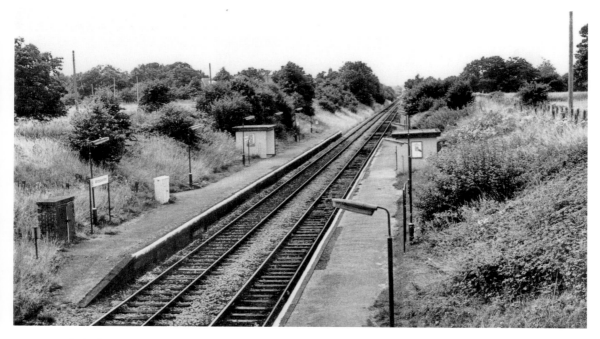

Whitlocks End, view Up, 14 August 1993. *Author*

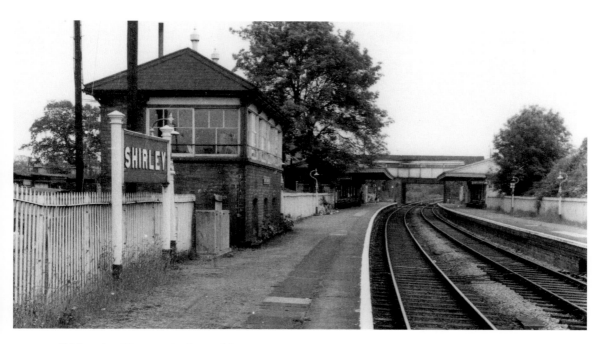

Shirley, view Up, *c.* 1963. *Lens of Sutton*

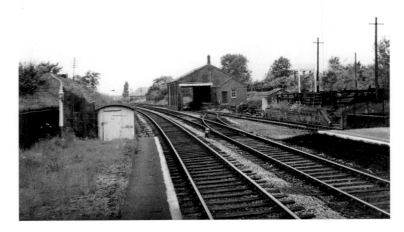

Shirley, view Down, 5 June 1968. The goods shed still stands, though it had been closed on 6 July 1964. The cattle pen is on the right and the loading dock on the far right. *D. Payne*

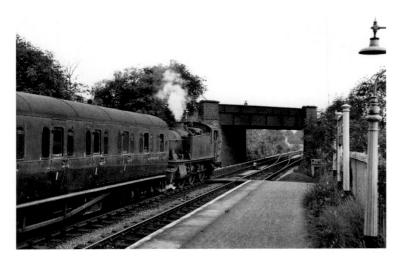

5101 class 2-6-2T No. 4126 (84E Tyseley) leaves Shirley with the 7.10 p.m. Birmingham (Moor Street) to Henley-in-Arden, 8 August 1959. No. 4126 was withdrawn from Tyseley in January 1962. *Michael Mensing*

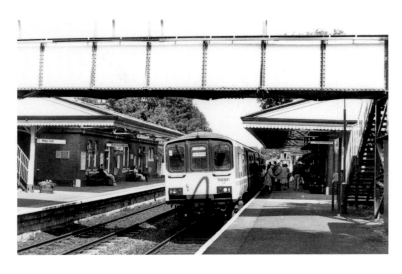

Sprinter No. 150011 at Shirley with the 11.22 Birmingham (Snow Hill) to Stratford-upon-Avon, 14 August 1993. Notice the signal box at the far end of the platform. *Author*

Rowington Junction to Henley-in-Arden

The mixed gauge branch from Rowington Junction, on the Birmingham to Leamington Spa line just south of Lapworth, to Henley was started by the Henley-in-Arden Railway, authorised on 28 June 1861. In 1866, funds ran out and the half-finished earthworks became overgrown in places by trees and undermined by rabbit burrows, thus forming a playground for children of the district. The scheme was revived by the Henley-in-Arden and Great Western Junction Railway incorporated on 5 August 1873. This concern in turn made little progress. An Act of 23 June 1884 revived the lapsed powers and changed the name to the Birmingham and Henley-in-Arden Railway. The contractor's engine used to move spoil and building materials reached its working site by running under its own steam along the road from Bearley to Henley, rails being laid in front of it and lifted immediately it passed. It gained the terminus along Henley's main street.

The branch opened to passenger traffic on 6 June 1894 and to goods on 2 July. Speed on the branch was restricted to 20 mph, reduced to 10 mph on the 1 in 55 descent to Henley. The branch, which had always been worked by the GWR, was absorbed by that company on 1 July 1900. The passenger station at Henley closed on 1 July 1908, trains then using the 700-yard link to the new station on the North Warwickshire Railway. The goods yard remained open until 31 December 1962, and was reached by a new line linking the Henley branch with the North Warwickshire line brought into use in July 1907. As a wartime economy measure the Henley branch was closed temporarily on 1 January 1916, from just south of Rowington Junction to north of Henley Goods Junction. This closure was made permanent a year later and the track lifted in May and June 1917.

In the *Great Western Railway Journal* No. 64, Mike Young reveals that the branch was at least partly relaid during the Second World War. Explosives were carried from South Wales to factories north of Birmingham where they were inserted into bombs and shells. These trains were dangerous and when air raids were expected in the Birmingham area, such a train needed to be kept as far from habitation as possible. The Henley branch was selected as having the characteristics of being away from a main line, running through a relatively sparsely populated district, while its three, fairly long cuttings provided that in the event of an explosion, most of the blast would be deflected upwards.

The branch had been closed for about twenty-five years, but to minimise visiblity from the air, the least possible growth clearance was carried out. In times of high traffic flow, the branch also became a useful refuge for less urgent trains. For approximately a year prior to the D-Day invasion, several complete trains of armoured vehicles were stored there. Shortly after D-Day the rails were lifted and once again reputedly sent to France. The double branch at Rowington Junction remained until 9 June 1968 as two sidings.

In readiness for the opening of the Henley branch, Lapworth (Kingswood until 1 May 1902) had its platforms extended in 1894 and a bay line added at the east end of the Up platform and the west end of the Down platform, branch trains using the main line for 1½ miles to Rowington Junction. Leaving the main line at Rowington Junction, track was double for half a mile before becoming single. The branch descended at a gradient of 1 in 60, followed by an equally steep rise. It passed Bushwood, not far from the birthplace of Robert Catesby, leader of the Gunpowder Plot conspiracy, and entered a deep cutting. At the centre of this commenced a long falling gradient of 1 in 55, extending almost to Henley. As the early morning train on 4 September 1899 approached this cutting, its brakes failed. It careered down the incline, through the stop block at Henley and came to rest in the field beyond. Fortunately few passengers were on the train and there were no serious injuries.

The terminus at Henley had a single passenger platform, while in the goods yard there was a shed and a cattle pen. The brick-built, single-road engine shed closed in July 1908. Following the opening of the branch, Henley became a favourite destination for excursionists from Birmingham, particularly school parties and sometimes no less than three special trains could be found in the station. Each train consisted of eight or nine bogie coaches drawn by a 0-6-0ST. In April 1910, the normal branch service consisted of eight Down and Seven Up trains on weekdays only.

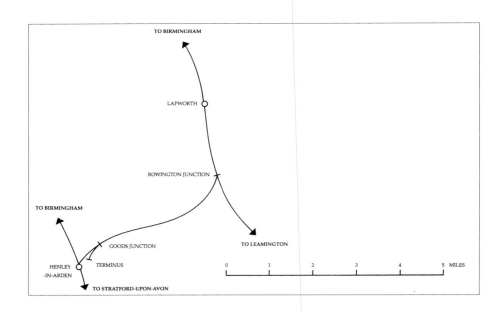

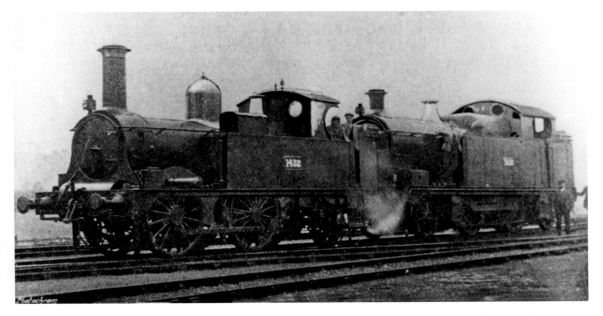

517 class 0-4-2T No. 1432 and 36XX class 2-4-2T, probably No. 3601, on the Henley-in-Arden branch in 1902. Although the original picture was captioned 'Ancient and Modern', No. 1432 (built in September 1877) was not withdrawn until October 1932, nineteen months after No. 3601, which had been built in February 1902. The 2-4-2Ts, principally designed for fast suburban trains in the Birmingham area, were superseded by the larger 2-6-2Ts. *Author's collection*

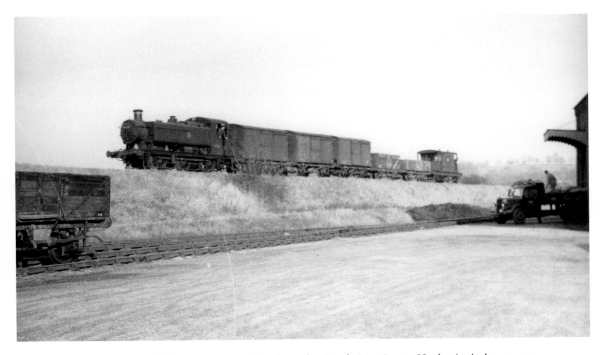

94XX class 0-6-0PT No. 9432 proceeding from the Goods Junction to Henley-in-Arden, *c.* 1954. *M. E. J. Deane*

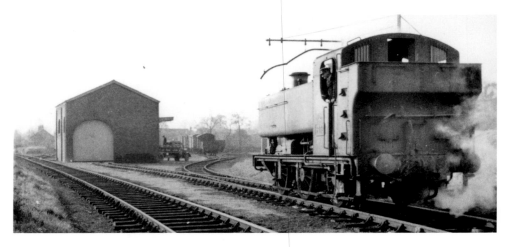

Henley-in-Arden, *c.* 1954: view towards the old passenger station which can be seen in the distance to the left of the goods shed. The locomotive is No. 9432. Notice the shunter's pole on the coal bunker. *M. E. J. Deane*

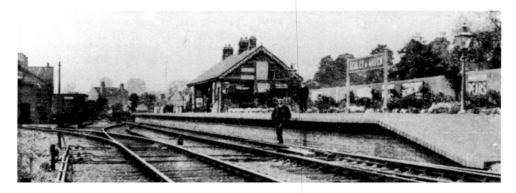

Henley-in-Arden, *c.* 1906. A locomotive coal wagon stands beside the engine shed. *Author's collection*

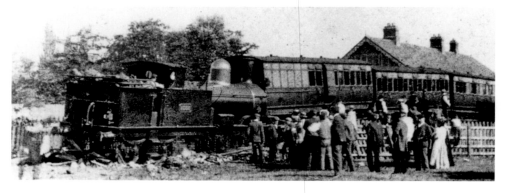

A mishap at Henley-in-Arden, 4 September 1899. 3521 class 0-4-4T No. 3556 in the field beyond the station. This locomotive had an exceptionally interesting history. Built in July 1889 as a broad gauge 0-4-2ST, it was found to be unstable so in August 1890 was converted to a 0-4-4T. It was adapted to standard gauge in February 1892. Still unstable, it was rebuilt as a 4-4-0 tender engine in August 1901 and finally withdrawn in September 1923. *Author's collection*

Bearley to Alcester

The Alcester Railway was authorised on 6 August 1872 to run from the Stratford-upon-Avon Railway at Bearley to the Evesham and Redditch Railway at Alcester. Following a meeting at Paddington in February 1873, William Clarke was appointed engineer, though shortage of finance caused the start of construction to be delayed until 1875 when Messrs Scott & Edwards of Melmerby, Yorkshire, were appointed contractors. Initially, a terminus at Alcester was planned, but then the more economic alternative of using the MR's station for an annual rent of £150 and paying a proportion of the working expenses was found a satisfactory solution. The Alcester Railway opted for a turntable and two-road locomotive shed to service the couple of locomotives, but William Clarke advised the company to have a single-road shed and defer the turntable until after the line was opened. The shed cost £733 19s 4d. Steam from the branch tank engine was used to pump water from the nearby River Arrow. The contractors worked on the line so speedily that the Board of Trade inspection took place on 25 August 1876, and the line opened to public traffic on 4 September. The Act stated that the GWR would work the line in perpetuity, so the company owned no locomotives or rolling stock. An Act of 22 July 1878 vested the company in the GWR and Stratford-upon-Avon Railway companies.

Prior to the First World War, royalty and gentry travelled to Alcester station while on visits to the Marquis of Hertford's Estate at Ragley Hall, only 1½ miles from the station.

The opening of the North Warwickshire line affected the branch, as west of Bearley it created a triangular junction and in the vicinity of Bearley North Junction used the formation of the Alcester branch for 250 yards. Bearley to Bearley North Junction was temporarily taken out of use from 5 June 1907 until 9 December 1907, during which period trains from Bearley to Alcester reversed at Bearley West Junction using the new line from West Junction to North Junction, which opened 5 June 1907.

As a wartime economy measure Alcester locomotive shed closed on 1 November 1915, the branch engine being transferred to Stratford-upon-Avon depot. The branch's passenger and mixed train service was withdrawn on 1 January 1917, the line being entirely closed and the track lifted in March.

As a result of local pressure, on 18 December 1922 the line was reopened from Bearley to Great Alne for both passengers and goods, a new halt at Aston Cantlow being opened on this date. On 1 August 1923, the branch was reopened through to Alcester. Although it had originally operated on the 'train staff without ticket' system, re-opening brought in the electric token. The service of six or seven trains each way daily was worked by steam railmotors. These were later replaced by auto trains.

On 25 September 1939, the public passenger service from Bearley to Alcester was withdrawn, but it was not quite the end of a passenger service on the branch, as following the Coventry Baedeker raid, the Maudslay lorry factory moved to the grounds of the manor house at Great Alne. Great Alne was opened as an unadvertised halt in July 1941 for Maudslay workers. Trains ran from Leamington in connection with services from Coventry; these specials continued until 3 July 1944 when buses were substituted. The branch was then worked on an 'as required' basis, including sugar beet traffic from Great Alne to Kidderminster sugar refinery. It was then utilised for storing crippled wagons until closure on 1 March 1951, a length of branch at each end being retained until August 1960 as a siding. The Bearley North curve was kept for use when a diversion was needed from the main line. This North curve was also used occasionally for stabling Royal specials overnight – Princess Margaret stayed there on 10 March 1954, and Prince Philip on 23 October 1959. The curve was closed on 20 November 1960.

Leaving the two platform station at Bearley, rather unusual for a GWR junction station as it did not have a bay platform, a train for Alcester curved round a single line to what became Bearley North Junction to join the North Warwickshire line. It passed under the thirteen-span Edstone Aqueduct, erected in 1813 and carrying the Stratford-upon-Avon Canal. Here the branch engine took water from the canal, a wheel-operated valve controlling supplies. Originally a filter prevented fish entering the locomotive's tanks, but this disappeared in time.

The second longest aqueduct in Britain, it was designed by William Whitmore and opened in 1816. The cast iron trough, 8-ft 10-in wide and 5-ft deep, was supported by cast iron beams spanning slender brick piers. Fourteen spans of 34 ft 3 in gave a total length of 479 ft, exceeded only by Thomas Telford's 1,027-ft-long Pont Cysyllte Aqueduct. The towpath was carried alongside the trough, level with its bottom on an extension of the trough baseplate. With a maximum height of 33 ft, it crossed road, stream and railway.

The height of the aqueduct caused Bearley North Junction to have a signal 50 ft tall – unusually lofty for the GWR, with a repeater arm fixed at a height of 20 ft.

Aston Cantlow Halt consisted of a sleeper-built platform and corrugated iron hut. When the halt was authorised on 1 June 1922 its cost was estimated to be £327. About a mile beyond, the line crossed the River Alne, and floods on

31 December 1900 closed the branch for a week. Great Alne station had a very domestic-looking two-storey building with the station-master's house on the single platform. The station awning was curiously off-centre leaving the main entrance uncovered. A goods loop adjoined and dispatched flour from the local water-powered mill. The line crossed the River Arrow by a girder bridge curving southwards before becoming double and joining the MR over which the GWR had running powers to Alcester station. Beside the junction was a one-road engine shed with brick walls and a slate roof. The pump house was alongside, steam being supplied by the branch engine, usually an 0-4-2T. Following the shed's closure on 1 November 1915, the branch was worked by an engine from Stratford. With the line's reinstatement, Alcester shed reopened on 1 August 1923, but finally closed on 27 October 1939. Alcester station had separate booking offices for MR and GWR passengers.

The train service showed little change over the years. In 1876, six return trips were made on weekdays only, five each way in 1887 and 1910, and six in 1938, the only variety being the times taken for the journey being twenty minutes, seventeen minutes and twenty-five minutes respectively.

The branch was originally worked by outside frame 0-6-0STs, then various 0-4-2Ts including No. 203 early in the twentieth century, followed by No. 537 and finally No. 4848. Usually the engine hauled an auto coach, the locomotive being at the Bearley end. In 1938, of the six trains each way, two were mixed, the latter having a brake van branded 'Bearley RU'. The auto car made one through trip to Stratford on Mondays to Fridays and three on Saturdays.

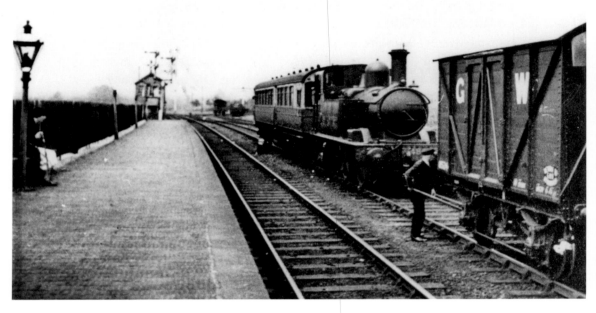

48XX class 0-4-2T No. 4801 at Bearley Junction, *c.* 1935. When it pushed the autocar to Alcester, it probably drew these vans behind the engine. *M. E. J. Deane*

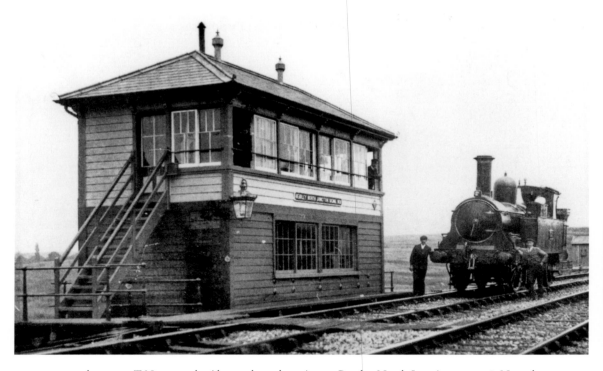

517 class 0-4-2T No. 523, the Alcester branch engine, at Bearley North Junction, *c.* 1908. Note the lamp on the signal box to assist collecting the single line token at night. *Author's collection*

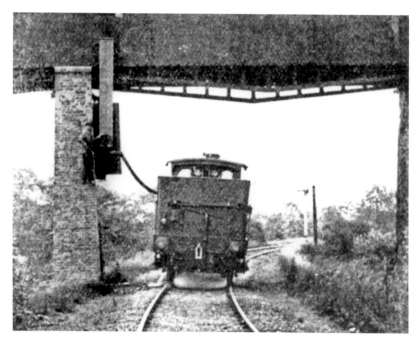

The Alcester branch engine taking water at Edstone Aqueduct, *c.* 1900. Notice the fireman up the ladder controlling the water valve. *Author's collection*

Great Alne, 7 June 1954, the track being just visible through the undergrowth. The view towards Bearley. *Lens of Sutton*

Bibliography

Baker, A. *An Illustrated History of the Stratford on Avon to Cheltenham Railway*, Oldham, Irwell, 1994

Biddle, G. and Nock, O. S. *The Railway Heritage of Britain*, London, Michael Joseph, 1983

Bradshaw's Railway Manual, Shareholders' Guide & Directory (various years)

Bradshaw's Railway Guide (various years)

Boynton, J. *Rails Across the City*, Kidderminster, Mid England Books, 1993

Boynton, J. *Shakespeare's Railways*, Kidderminster, Mid England Books, 1994

Clark, R. H. & Potts, C. R. *An Historical Survey of Selected Great Western Stations*, Vols 1-4, Oxford, OPC, 1976-85

Clinker, C. R. *Register of Closed Passenger Stations & Goods Depots*, Weston-super-Mare, Avon-Anglia, 1988

Christiansen, R. *The Regional History of the Railways of Great Britain Vol. 13 Thames & Severn*, Newton Abbot, David & Charles, 1981

Cooke, R. A. *Atlas of the Great Western Railway*, Didcot, Wild Swan, 1997

Cooke, R. A. *Track Layout Diagrams of the GWR & BR WR*, Harwell, Author, Section 18, 1997, Section 31 1978 and Section 33, 1976

Goode, C. T. *The Birmingham & Gloucester Loop*, Hull, Author, 1998

Gough, J. *The Midland Railway, A Chronology*, Mold, RCHS, 1989

Hitches, M. *Worcestershire Railways*, Stroud, Sutton Publishing, 1997

Lawton. E. R. & Sackett, M. W. *The Bicester Military Railway*, Sparkford, Oxford Publishing Company

Lyons, E. *An Historical Survey of Great Western Engine Sheds, 1947*, Oxford, OPC, 1974

McDermot, E. T., Clinker, C. R. & Nock, O. S. *History of the Great Western Railway*, London, Ian Allan, 1964 and 1967

Midland Railway System Maps, Vol. 4 (The Distance Diagrams), Teignmouth, Peter Kay, no date

Midland Railway System Maps, Vol. 6 (The Gradient Diagrams), Teignmouth, 1999

Mitchell, V. & Smith, K. *Bromsgrove to Gloucester including Ashchurch to Great Malvern*, Midhurst, Middleton Press, 2006

Mitchell, V. & Smith, K. *Stratford upon Avon to Birmingham (Moor Street) including Hatton to Alcester*, Midhurst, Middleton Press, 2006

Mitchell, V. & Smith, K. *Kidderminster to Shrewsbury*, Midhurst, Middleton Press, 2007

Mourton, S. *Steam Routes Around Cheltenham*, Cheltenham, Runpast Publishing, 1993

Robertson, K. *Great Western Railway Halts, Vol. 1*, Pinner, Irwell, 1990

Robertson, K. *Great Western Railway Halts, Vol. 2*, Bishop's Waltham, KRB Publications, 2002

Shill, R. A. (compiler), *Industrial Locomotives of the West Midlands*, London, Industrial Railway Society, 1992

Anon. *British Railways Pre-Grouping Atlas & Gazeteer*, Shepperton, Ian Allan, no date